Finding the Civil War

IN YOUR

Family Album

Finding the Civil War

IN YOUR

Family Album

MAUREEN A. TAYLOR

PICTURE PERFECT
PRESS

Finding the Civil War in Your Family Album

Copyright © 2011 by Maureen A. Taylor
www.maureentaylor.com

Published by Picture Perfect Press
www.PicturePerfectPress.com

ISBN 978-0-578-07809-0

Book and cover design by cj Madigan, Shoebox Stories,
www.shoebox-stories.com

Printed in the United States of America

Table of Contents

Preface

I was thrilled when editor Allison Stacy and the staff of *Family Tree Magazine* asked me to write a chapter on photography during the Civil War for a new book *Life in the Civil War* (Family Tree Books, 2010). As I began researching all aspects of pictures taken during that time frame, I realized there was a lot of material to cover. While I presented an overview of photography during the war, I wanted to know more about the evolution of family photographs during that period to help individuals tell the story of those mysterious images in their family albums.

Back in middle school, I was asked to play Mary Todd Lincoln in a school play. I drove the local librarian to distraction trying to find information on clothing styles and hats worn in 1865. Then, I tried to recreate them at home. The end results didn't quite meet my expectations but I certainly learned a lot. I guess it was a foreshadowing of what I'd do in the future—photo identification.

There are always people to thank. At the top of the list are Allison, Diane and Jackie of *Family Tree Magazine* for giving me the original writing assignment. This book wouldn't have been possible without GenealogyBank. com, an extensive subscription newspaper database. I've spent entire days reading the news from the 1860s. With permission, I've included quotes from articles to provide social history details. Thank you, Tom Kemp! The Library of Congress Prints and Photographs [www.loc.gov] online database, especially the photographs in the Liljenquist Family Collection, enabled me to illustrate the points made in the text.

Thank you to Craig Scott, CG of HeritageBooks.com for his assistance with articles I've written about military uniforms. While he hasn't seen the chapter in this book, it's based on those writings. If there is an error, it's my fault. A hug for Footnote Maven [www.footnotemaven.com] who suggested I start collecting old magazines. I'm addicted to it! You can view *Godey's Lady's Book* on Accessible Archives [www.accessible.com]. (I use the site as an index to the magazines I own.) You can also view *Peterson's Magazine* on books.google. com.

Thank you to friend and colleague Midge Frazel for contributing her success story and reading the manuscript. Thank you also to Photo Detective blog [blog.familytreemagazine.com/photodetectiveblog/] reader Rachel Peirce for letting me use her story and images. Costume designer and historian, Betty Shubert, shared her knowledge of 1860s clothing.

Genealogist Pat Layton showed me her wonderful image of an unidentified soldier at the Federation of Genealogical Societies Conference in 2010. That image inspired me to look more closely at Civil War era images.

As usual I need to thank the people who supported me during this writing process—my family, friends, colleagues Jane and Kathy, and intern Stuart for scanning. A big thanks to the talented CJ Madigan of Shoebox-stories.com for design and Kathy Crosett for copyediting. Jane Schwerdtfeger contributed many photographs to this project and painstakingly read through the manuscript. Thank you, Jane, for pushing me to add more details.

I hope this book inspires you to look at your Civil War photographs in a new way and to go out and search for more.

If you have a success story to share, contact me through my website [www. maureentaylor.com].

Notes on the Cover

The image of the lovely young woman with a Mona Lisa smile belongs to Whit Middleton. His cousin, Lydia Giancotti, showed me the cased image during a consultation at the Florida State Genealogical Society Conference in Sarasota in November 2010. It's a stunning image of a mysterious young woman in a lovely bonnet. The mat covered up her secret. She's holding a picture of a young man in a Confederate uniform. Based on what little of his uniform is visible, the soldier in the **ambrotype** held by this woman appears to be with an artillery company. At this point, Whit's done a lot of searching in family materials looking for a clue to their identity and narrowed the list of possibilities to the surnames Newton and Munson, Middleton being a descendant of both family names.

I chose purple as the background color for the cover because of its significance during the Civil War. Purple was worn as a symbol of virtue and valor for the men who fought during the war.

Introduction

D o you own a photograph taken during the American Civil War, 1861-
1865? If so, that image tells the story of ancestral involvement in a
critical period of history. Whether it's a man in uniform or a woman with her
children, each photo has a story to tell. You can uncover that tale by studying
the details in the picture and by learning more about general history and family
genealogy during that period. If you're not sure whether your photo dates
from that timeframe, this book will help you determine when it was taken.
Identifying Civil War era pictures means studying the clues – a photographer's
work dates, clothing, tax stamps and military dress.

Photography was still a fairly new medium when the first shot was fired
at Fort Sumter on April 12, 1861. That shot not only began the war, it gave
a boost to the photo industry. Only twenty-two years before that pivotal
moment, Americans saw shiny reflective metal **daguerreotype** portraits for the
first time. In the 1850s, new formats became available – glass **ambrotypes**, iron
tintypes and paper prints. The war created an incredible demand for images
of loved ones and provided a boon to struggling studios and opportunities
for enterprising individuals who sought to capitalize on the public's desire for
photographs. As men went off to fight on both sides of the conflict, it was
common practice to sit for a portrait to leave as a remembrance. Similarly,
family members would pose for images to give their soldier a bit of home to
carry with them.

Two of the newer photo methods – card photographs and tintypes – had an advantage over older bulky cased images. They could be carried in a small pocket or enclosed in a letter. These thin images could also be inserted in a new invention, the photo album. While in some cases it's difficult to specifically date a picture to 1861-1865, the photo styles discussed in this book were available during that time frame. The photographs show the diversity of clothing in the mid-1860s. Few of us even today throw out all of our older clothing and replace our wardrobe with new items. The same was true for our ancestors. Head to foot fashion sense depended on economics, personality and availability. Whenever possible I've included fashion illustrations from nineteenth-century magazines such as *Godey's Lady's Book*. This information will help you date your photos.

Examine each detail of a photo to learn more about the image. The photographer's information tells you where the image was taken, but the photo itself (style, type and props) provides background on the time period. Uniform clues supply you with evidence of military service leading you to further explorations in military records. Fashion sense depicted in images can lead to an understanding of your ancestor's relationship to nineteenth-century design dictates, economic status, or clues to a family milestone such as a death or a wedding. There are many ways to look at a photograph and study its facts.

I have included images throughout this book and a gallery of pictures at the end of certain chapters. Each image has a caption. Use these images for comparison when trying to date your photographs.

By focusing on a specific time period, I have been able to explore photographic innovations during that time and to delve deeper into fashions of the era. The details and examples I write about in each chapter will help you date your photographs and learn more about your family photographs during a key period of American history.

Once I started this project, I discovered that over the years I'd written articles about finding photographs of Civil War ancestors and how to research photographs taken in those four years. I've included updated versions of my previous articles here.

You can use this book to study specific details present in your photographs such as clothing and photographic method but you can also gain an understanding of the time frame by reading the quotes from I've excerpted

from contemporary newspapers and magazines. If you come across an unfamiliar word, it may be listed in the glossary at the end of the book.

After you've examined your Civil War images, you'll need to find out more about your family using genealogical databases and historical records. With the one hundred and fifty year anniversary of the start of the Civil War occurring in 2011, there are numerous places to search for information. Ask family members, and then use the mega databases at Ancestry.com, Footnote.com and GenealogyBank.com. Don't forget to look at historical society websites to search for images and information. Lately, it seems that Civil War material is everywhere.

Label reads, "Harrison Grey Fiske, at 6 months". Circa 1861. This may depict the Harrison G. Fiske that appears in the 1900 U.S. Census, living in New York City. He was born in July 1861. In this photograph, Fiske wears a short dress fashionable for young babies. He sits in a photographic posing chair used for small children.

CHAPTER 1

——◆——

Photos in Your Family

The Civil War years brought photography into every household as relatives clamored for images of loved ones and their preoccupation with wartime photographs grew. Photography not only enabled individuals to preserve the faces of family and friends, it let them see battlefield dead. During the war, public fascination with pictures was insatiable.

Odds are pretty good that your Civil War-era ancestors posed for a picture. Thousands of photographers were in business – in small towns, big cities and on the road. Itinerant photographers traveled rural by-ways and set up temporary shops in wagons near military encampments. The 1860 United States Census enumerated more than 3,154 individuals who claimed photography as their sole occupation.[1]

Several different photographic methods existed during the Civil War. The decades-old daguerreotype was still in use, but newer methods such as tintypes and card photographs rapidly displaced heavy and fragile cased images.[2] Theoretically, a potential photographic client could choose the type of photograph to capture their visage. [Not all studios offered the full range of mid-nineteenth-century pictures; some specialized.] Old-fashioned daguerreotypes (a likeness on a shiny metal plate), glass ambrotypes, inexpensive iron photos known as a tintypes and small card photographs (cartes de visite) were all available.

Daguerreotypes

While daguerreotypes weren't as common in the early 1860s as in the previous two decades, it is possible that someone in your family sat for one in the early years of the war. This shiny reflective image on a metal plate must be held at an angle to clearly see the sitter.

After decades of trial and error, Louis Daguerre announced in 1839 that he'd created a permanent image on a metal plate. Newspapers printed the story and the news spread around the world. In 1840, Francois Gouraud, a contemporary of Daguerre, arrived in the United States. He traveled throughout the country giving demonstrations on how to create a daguerreotype, a photographic image on a silver plate.

A daguerreotype is a sheet of polished silver covered in light-sensitive chemicals and exposed to light. The final product was a unique, realistic portrait of an individual. The technology did not exist to make multiple images at one time. Instead, daguerreotypists learned to make duplicates of the image by having an individual sit for additional portraits or by making copies of the original. Mass production of daguerreotypes often became the responsibility of an engraver who made prints based on the image. By the time of the Civil War, other photographic methods had largely replaced the daguerreotype.

Ambrotype

In the early 1850s, English sculptor Frederick Scott Archer found a way to apply light-sensitive chemicals to glass, creating negatives. This wet collodion negative is the basis for the ambrotype. Three years later, John Cutting of Boston, Massachusetts, applied for three United States patents that resulted in the ambrotype.

An ambrotype consists of a piece of glass coated with a photo chemical known as collodion, a mixture of gun cotton and ether. The sheet of glass with the negative image is made positive by applying black varnish to the back. (Sometimes, fabric was used.) The image is then viewed as a positive. The rest of the image includes the cover glass, mat, case and preserver. By 1856, ambrotypes were widely available.

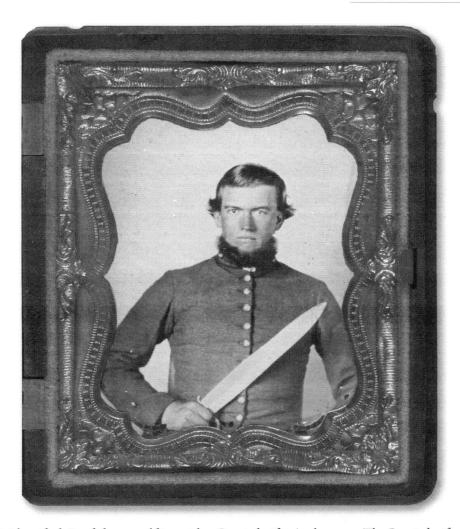

Unidentified Confederate soldier with a Bowie knife. Ambrotype. The Bowie knife was named for James Bowie, a frontiersman known for his knife-fighting ability in the 1820s and 1830s. He died at the Battle of the Alamo in 1836 during the Texas Revolution.

Just like the daguerreotype, ambrotypes were a reversed one of a kind image. (Some photographers utilized prisms or special lenses to correct the reversal.) Daguerreotypes were thinner than ambrotype glass so deeper cases were designed to display them.

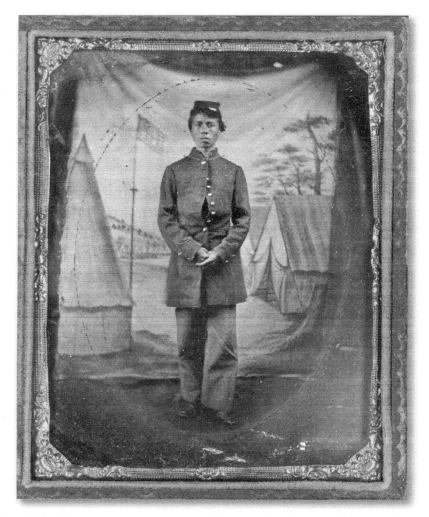

Unidentified African American Union soldier in a frock coat and kepi style military cap. He's standing in front of a draped backdrop on a dirt floor to depict a camp scene. According to the Library of Congress database record, the photo was taken by an itinerant photographer.

Thousands of ambrotype portraits exist from the Civil War period. Photographers who set up studios near troop encampments usually took cartes de visite (CDV) or tintypes, while established studios took ambrotype portraits. Ambrotypes were inexpensive to produce. For instance, most of the sources I consulted mentioned that a plain (not hand-colored) ambrotype could be obtained for about 25 cents while a small card photograph taken at an encampment could cost as much as $1.00. Despite the price difference, many soldiers preferred the easy to carry and mail tintypes and CDVs. [3]

Tintype

Unlike the daguerreotype and ambrotype, multiple tintypes could be made at a sitting. A tintype was inexpensive to produce, and it took less than ten minutes to walk out of a photographer's studio with one in hand. Some photographers used special multi-lens cameras to produce additional individual exposures. Tintypes, like daguerreotypes and ambrotypes, were not made using a negative.

The first photographic process invented in the United States resulted in tintypes or ferrotypes. The longevity of tintypes is surpassed only by the paper print. A chemistry professor in Ohio patented the tintype process in 1856 and it survived until the middle of the twentieth century. While the name suggests the metal used in the process was tin, photographers actually worked with iron sheets cut into standard sizes coated with light sensitive chemicals. Early tintype sizes initially corresponded to ambrotypes and daguerreotypes, making it easy to place them in cases. Other sizes were introduced later. The "thumbnail" or gem tintypes were made to fit into a specially-created album. These tintypes were literally no larger than a thumbnail, thus their nickname. Tintypes are usually found in either a case, a paper sleeve with a cut-out for the image, or lack their protective covering.

Tintypes were enormously popular during the Civil War. Unlike bulky daguerreotypes, and fragile ambrotypes, tintypes were durable. They could easily be included in a letter and mailed home.

Cartes de visite (CDV)

Roughly 4 x 2 inches in size, these small photographs were extremely popular. The name refers to their dimensions. They are about the size of a visiting card. French photographer, Andre Adolphe Eugene Disderi, patented the process in November 1854. By 1859, CDVs were widely available in the United States. Disderi also patented a method for printing ten images on a single sheet as well as a camera with four lenses for multiple portraits. John Plunkett, contributor to the *Encyclopedia of Nineteenth-Century Photography* credits CDVs with making photography a mass medium[4]. Suddenly, collecting images of family, friends and the famous became a common hobby. It is not unusual to find multiple CDV portraits of a single person taken on the same day.

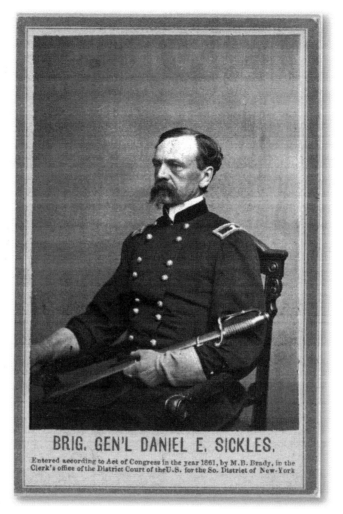

Brigadier General Daniel E. Sickles, E. & H. T. Anthony. 1861. This is the type of card sold by booksellers and stationery stores or even ordered directly from Anthony. Individuals collected CDVs of famous generals. Sickles was promoted to Brigadier General of Volunteers, New York Excelsior Brigade in September 1861, the rank he held until his promotion to Major General in November 1862.

Reproduction of Card Photographs

During the war, photographs couldn't be mass produced in the contemporary sense or enlarged. Each required development of individual sheets which slowed down the production process. The size of the photographic sheet corresponded to the negative.

For 15 cents apiece, a customer could purchase CDV images of encampments at Bull Run or portraits of Lincoln and his generals. The last page of the February 1864 issue of *Godey's Lady's Book* (See illustration) contains a list of available portraits –15 cents each, eight for $1.00 or twenty for $2.00 with free shipping. They were available from Godey's publisher.

Watch your albums for these images. A picture of General Grant in your family photo album suggests someone in the family bought the picture, not that he's necessarily a relative.

Elegant Cartes de Visite

OF NOTABLE PERSONS, CHOICE PICTURES, AND WORKS OF ART.

☞ *Sent by mail, postage free, at 15 cents each. Eight for $1. Twenty for $2.*

The publisher of the Lady's Book has made arrangements to furnish, through his Philadelphia Agency, an extensive variety of these elegant Photographic novelties, now so widely popular. They are of the highest tone and finish, and all who order through this source may rely on getting the best.

A printed Catalogue, embracing several hundred subjects, will be sent on application. Among these subjects are the following :—

Officers of the Army and Navy.	General Dix.	Vandyke.	Madonna San Sisto, from Raphael.
General Scott.	" Wool.	Raphael.	phael.
" Halleck.	Admiral Dupont.	George D. Prentice.	Infant Saviour, from Murillo.
" Rosecrans.	" Farragut.	Mad. De Stael.	Virgin of Seville.
" McClellan.	" Foote.	J. G. Whittier.	Family Worship.
" Burnside.	" Goldsborough.	Nath. Hawthorne.	Past and Future.
" Grant.		Edward Everett	Ruth.
" Fremont.	*Civil Officers.*	Marie Antoinette.	Rachel.
" Anderson.	President Lincoln.	Mary Queen of Scots.	Bathsheba.
" Butler.	Vice-President Hamlin.	Isabella of Spain.	Esther.
" Banks.	Secretary Chase.	Anna Boleyn.	Witch of Endor.
" Buel.	" Seward.	Washington, from Stuart.	Miriam.
" Heintzelman.	" Welles.	" " Peale.	Good Shepherd, by Murillo.
" Hunter.	" Stanton.	" " Trumbull.	The Young Chevalier.
" Lyon.		Mrs. Washington, by Stuart.	New Year's Gift.
" Sumner.	*Authors, Artists, and Distin-*	" " at twenty-	Mother's Vision.
" Hooker.	*guished Personages.*	five.	Believer's Vision.
" Mitchell.	Wm. C. Bryant.	Napoleon I.	Spring, by Thorwaldsen.
" Meagher.	H. W. Longfellow.	Eugenie.	Summer,
" Corcoran.	Tennyson.	Queen Victoria.	Autumn,
" Cox.	Robert Browning.		Winter,
" Lew. Wallace.	Mrs. Browning.	*Copies of Pictures.*	Beatrice Cenci, from Guido.
" Curtis.	N. P. Willis.	Mercy's Dream.	The Motherless.
" Doubleday.	Theodore Winthrop.	Evangeline.	Rebecca. from Ivanhoe.
" McDowell.	Bayard Taylor.	May and December.	Madge Wildfire.
" Pope.	Walter Scott.	Infant St. John.	Suffer little Children.
" Mansfield.	Shakspeare.	Longfellow's Children.	Blessed that Mourn.
" Sigel.		Madonna, from Corregio.	

At the above low price ladies can furnish their Albums at a comparatively small cost, with a variety of choice portraits and pictures.

Inside back cover of Godey's Lady's Book. January 1864.

Stereographs

Stereograph cameras captured identical images side by side and when viewed through a special device, the stereopticon viewer, stereo photographs become three-dimensional and realistic. These images rarely depict family portraits or scenes. More often, they portray views of foreign countries or Civil War battlefields. After the war, these sets continued to be popular.

Large photographic retailers such as Anthony and Co. sold stereographs of the war. Sets cost approximately $4.00 a dozen with hand-colored stereos selling for a bit more.[5] Photographers such as Alexander Gardener shot stereo negatives at Gettysburg, but printed them in two different formats – as a double-sided stereo image or a single side cartes de visite.

Major Characteristics			
DAGUERREOTYPE	AMBROTYPE	TINTYPES	CARTES DE VISITE
Mirror-like surface	Negative on glass; appears as a positive image	Negative on iron; appears as a positive image	Albumin or carbon prints— photo chemicals on paper
Must be held at an angle to be seen	Backed with a dark background	Fixed on a black metal background	Mounted on thin card stock
Usually cased	Usually cased	Paper mat or case	Occasionally found in a case
Image is reversed*	Not reversed*	Image is reversed*	Not reversed
1839	1854	1856	Process introduced to United States in 1859
*Photographers developed methods to correct the reversal using special lenses and prisms.			

Mats and Sleeves

During the war, customers left photographic studios with patriotic themed images such as cased ambrotypes surrounded by a mat embossed with flags and stars. Cartes de visite and tintypes also often featured national symbols of patriotism on the back or on the paper mat. Flags, stars, and an eagle were popular icons.

Card Stock and Decorative Elements

Throughout the Civil War, borders of card photographs were either plain or decorated with one or two lines along the edges. Card stock colors were white, tan or gray, but the latter were plain edged. Yellow was not an unusual color for stereographs.

Poses

Photographers used a variety of headrests and photographic apparatus to hold subjects in place. These strategies lent stiffness to poses. You can spot the wooden legs on the floor near the subject's feet. Usually individuals posed alone or in very small groups in a vertical shot. It's unusual to see horizontal cartes de visite images.

Props and Backdrops

Simple studio settings included a draped curtain, oil cloth or carpet on the floor, a chair and a table. These types of props were part of conventional portraiture in both photographs and paintings. Prevalent furniture styles in the Civil War period included Rococo Revival, Naturalistic and Renaissance Revival.

Naturalistic and Rococo Revival furniture pieces feature carvings of flowers, grapes, oak leaves and roses. You'll also see scrolls and shell designs. Carvings are often intricate. Wavy lines are present in chair backs, table legs and even couch backs. The Renaissance Revival style also features curves with carved designs often in the form of fruit or flowers.

Painted backdrops were not new. They were used in theatrical settings and in the background of painted portraits. In the 1860s, photographic backdrops typically featured outdoor scenes.

Fort Sumter, Charleston Harbor, no. 624. Photographer, George Stacy. 1865. The image is mounted to yellow card stock. Stacy took stereographs from the late 1850s to the mid-1860s. Views of the fort continued to be popular after the war.

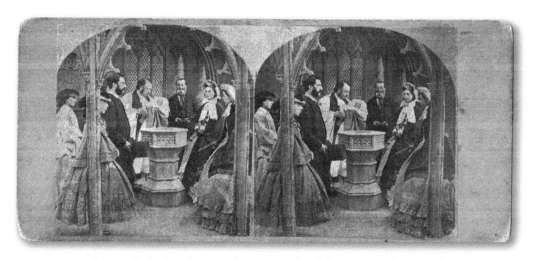

Stereographs depicted idealized scenes from everyday life as well. This card by Boston photographer Joseph L. Bates depicts a baptism.

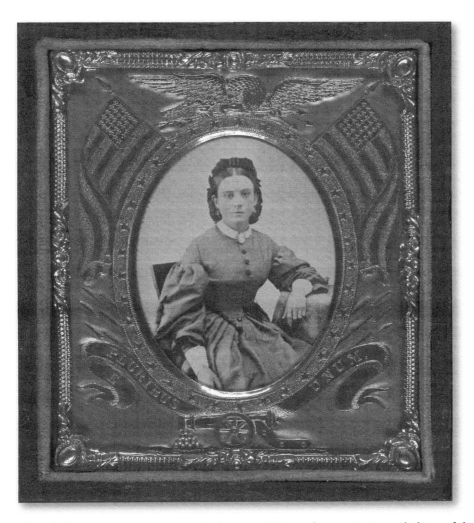

Unidentified woman. 1861-1865. Ambrotype. Notice the patriotic symbolism of the flags, eagle at the top, "E Pluribus Unum" banner, and cannon at the bottom. She is wearing a hairnet that features a bow at the top of her head. On the reverse is a poem Love Ne'er Dies by S. W. Pearce.

Watch for flags in the background of Civil War images. Count the stars on the field of blue to determine if the flag is current for the period or is from an earlier time frame. You can compare the flags in your photo to images and information online at [www.usflag.org]. For instance, on July 4, 1861, the U.S. flag gained a star for the addition of the state of Kansas; two years later Minnesota joined the Union adding the 35th star.

Unidentified tintype of a woman. This particular style of mat has a printed frame around the image. She wears a patterned dress of cotton fabric and a high brimmed spoon bonnet.

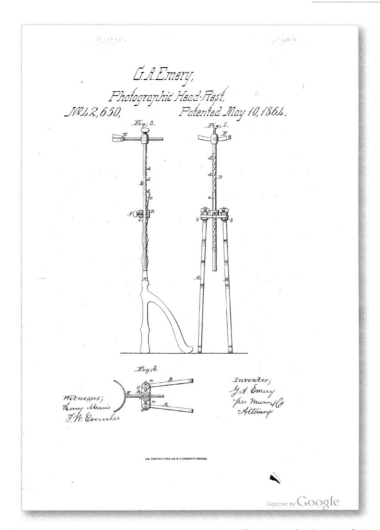

Photographic patent no. 42,650. Improvement in Photographer's Head-Rests submitted by G. Alexander Emery, of Boston, Massachusetts. Dated May 10,1864. Patent papers featured a drawing of the device as well as an explanation of how it worked. Emery claimed this device was superior to those currently in use because it wasn't visible in a photograph like those with wooden bases. A person's head would rest in the clamps enabling them to stay still for the exposure.

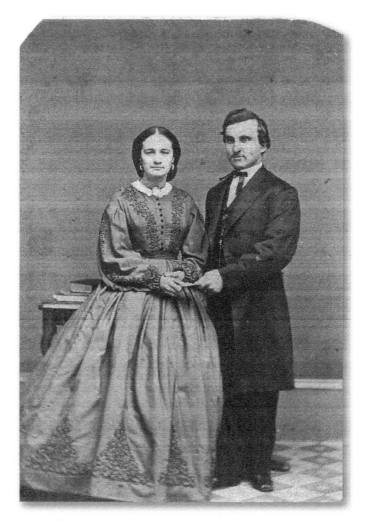

Unidentified couple, late 1860s. Morgan & Brusstar, 1109 Spring Garden St., Philadelphia. Notice the wooden brace behind the husband's foot. Her dress is trimmed with **soutache** *braid and he wears a long frock coat. They are holding a letter. Inclusion of this as a prop had significance to the couple, but that's been lost now. The lack of a revenue stamp on the back suggests it was taken before August 1864. Edward R. Morgan and his partner were in business from 1864 to 1866.*

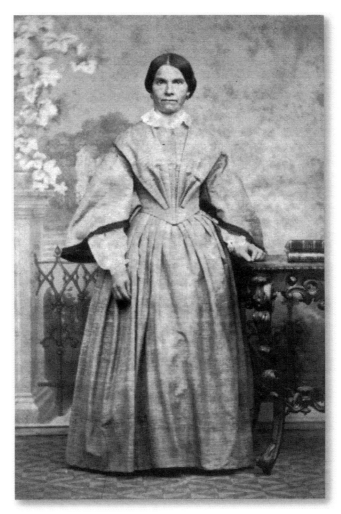

Unidentified woman, J.L. Brush, photographer, New Vienna, Ohio. In this studio, the photographer used a table and a few books. The addition of a painted backdrop with an outdoor scene and the wrought iron fence makes it seem as though the image was taken outdoors or on a porch. The bodice style dates back to the 1840s, but the sleeves date to the early to mid-1850s. The rest of the image information suggests that the picture actually dates from the 1860s. Her attire is a reflection of her conservative dress. This was a type of everyday dress.

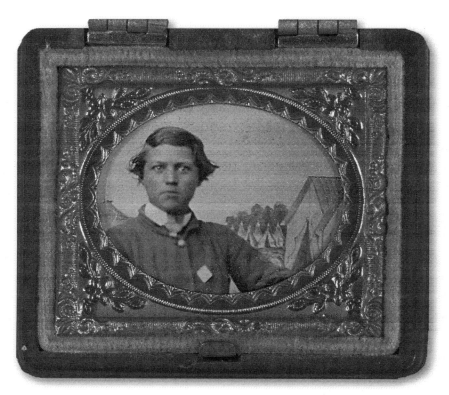

Unidentified Union soldier with 3rd Corps badge, in the background is a painted backdrop of military tents. Fabric badges were worn on top of kepi hats, on the left side of the cap or on the left side of their shirts. Third Corp badges were blue.

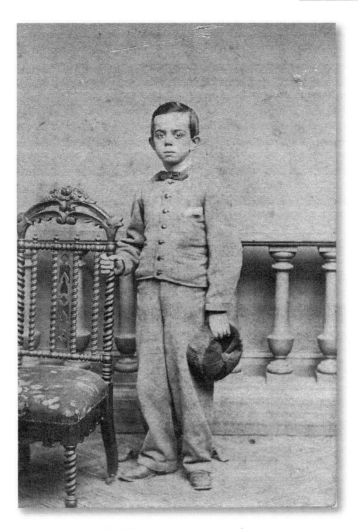

Unidentified child, photographed by R.R. Priest, Hightstown, N. J. 1864-1866. He wears a boy's suit – waist length jacket, long trousers and a small tie. He carries a small round hat.

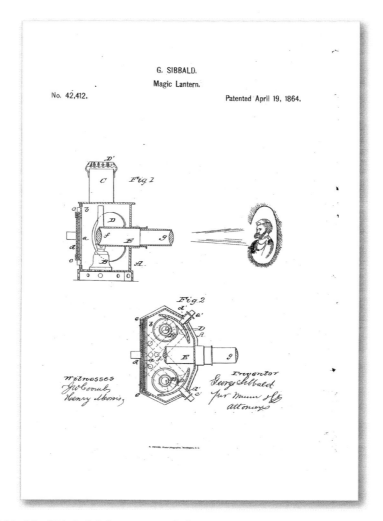

George Sibbald of Philadelphia patented this improvement in Magic–Lanterns in 1864. This drawing shows how a magic lantern projected images.

Photographic Innovations

In the 1840s, sisters Kate and Margaret Fox, claimed to communicate with the dead and during the war years this type of spiritualism captured the public imagination. The high fatality rate in wartime encouraged the belief. In the summer of 1862, the first "spirit" photographs appeared. The public loved these images. Photographers used a double exposure and other techniques to lead the viewer to believe that a ghostly apparition was captured by a camera.[6] Even educated individuals believed these photographic sleights of hand because they couldn't discern how they were created. These spirit pictures were investigated by doctors and other photographers. After the war, photographer William H. Mumler of New York was tried and acquitted of public deceit for producing this type of image. Extensive examples appear in *The Perfect Medium: Photography and the Occult* by Clement Cheroux, Pierre Apraxine et al.

Photography also became a form of public entertainment. A device known as the magic lantern allowed for the projection of glass slides. This eighteenth-century invention initially used candlelight for illumination, but by the Civil War era, bright electric arc lighting was available. Magic Lantern festivals were held in various parts of the country and advertised as entertainment for children. The Langenheim Brothers of Philadelphia made glass transparencies of engravings of war scenes and projected them using a magic lantern.[7] This subject matter was best suited for adults.

How to Make Magic Lantern Slides By the Process of Diaphanie

The colors used in painting magic lantern slides are those which are transparent such as the lakes, sapphires, Prussian wine, distilled verdigris, gamb (sic) & c. ground in oil and tempered with mastic varnish. Coal varnish may be used in the dark shades. Draw on paper the subject you intend to paint and fix at each end to the glass; trace the outlines of the design with a fine hard pencil in strong tints in their proper colors, and when these are dry, fill in their proper tints, shade with black, bistre [a shade of grayish brown] and varnish brown as you find convenient.[8]

While actual moving films had not yet been introduced, photographic devices simulated movement using projected still images. A series of paper prints were mounted in a circular device known as a zoetrope, which rotated to project a moving image, much like a flip-book.

Photography continued to enthrall the public who quickly found new uses for the medium. For instance, police thought that a photograph of a murdered man's retina could reveal the last person the deceased saw – his murderer. Experiments to prove this theory took place in German Township, Indiana and in France. The reporter commented that:

"Notwithstanding we have heard of these strange things, we were still under the impression that 'dead men tell no tales.' Until a recent experiment has shaken our faith, and almost convinced us that, though dead, men may yet speak."[9]

From 1861 to the end of 1864, at least ninety-six patents were submitted for improvements to photographic methods or for new devices. Picture-buttons, mats, cases and an apparatus for enlarging photos were all invented and patented in those years. You can search for and view these patents on Google. A concise list of all photographic patents granted during the forty year period ranging from 1840 -1880 appears in Janice G. Schimmelman's *American Photographic Patents: The Daguerreotype & Wet Plate Era, 1840-1880.*

While photographs were produced on metal, glass, and paper, improvements were constantly being invented. An announcement in the January 16, 1863 *Hartford Courant* proclaimed that Messrs. Prescott and Gage could now take photographs on thin sheets of porcelain. It also mentioned that the two men could produce photographs on "plain window glass."[10]

CHAPTER 2

Photo Albums

On May 14, 1861, F. R. Grumel of Geneva, Switzerland submitted a patent in the United States for a photographic album (patent number 32,287). His layout design allowed for a single image or engraving to be inserted in each page of the album. A mere year later, Americans were crazy for photograph albums. Initially, high-priced albums were imported from France and Germany, but it wasn't long before factories in the United States produced copies. An article in the *Oregonian* proclaimed: "Everybody, now-a-days, must have a Photograph Album, to be in fashion. It is an indispensable article for preserving the 'counterfeit presentment' of one's friends and constitutes one of the chief and most interesting ornaments of the parlor."[11] Albums were available in a variety of retail outlets including bookstores as well as through mail order.

Individuals began collecting photographs. For genealogists, a quote from the article below suggests we should look at our albums critically and carefully. "May it not be others, ny with many, as it was with a young person who lately showed us several pictures of young ladies. After looking at them and admiring them, we began to interrogate him whom they represented, and his reply from first to last was that he 'did not know.' "[12]

Our ancestors arranged photos of individuals – famous folks, friends and family – in these albums. In some cases, the images represented personal interests such as places visited, art pieces or even scantily-clad women.

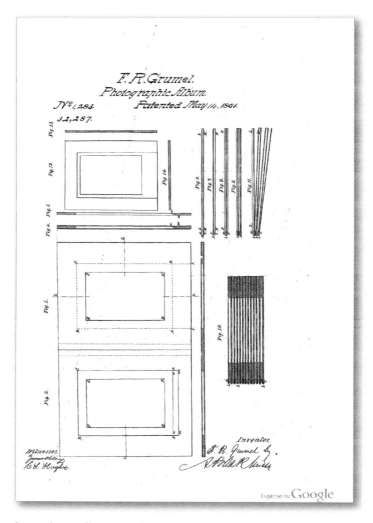

Grumel's patent for a photo album. 1861.

Photo albums occupied a prominent place in households – on the corner table and in the parlor. Visitors added their images to the collection or simply viewed the images already there. An 1864 article in the *Springfield* (Massachusetts) *Republican* proclaimed that "Civilians cherish them as among their dearest treasures and hardly a soldier goes forth to battle but carried one in his pocket, to be his shield, perhaps, in the hour of conflict, but at any rate his solace and delight in the monotony of the camp or on the lonesome and dangerous picket line."[13] Advertisements suggested that every soldier should have an album. They could be ordered and mailed directly to them.

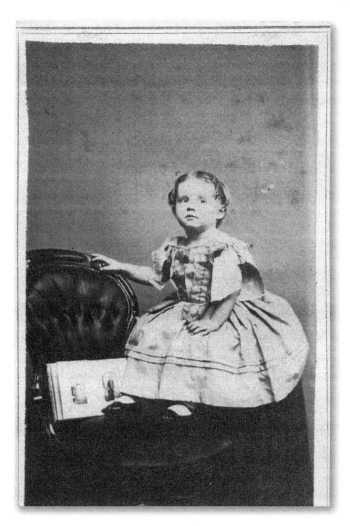

Unidentified child posed sitting on a small table with a photo album on a chair.
William Richardson, photographer, Williamsburg, Long Island.

By 1864, albums came in all shapes and sizes including small palm-sized booklets perfect for tiny gem tintypes, also known as "thumbnails." Small card albums held twelve images, while large ones held four on a page for a total of 200. In 1862, "The American Photograph Albums" manufactured by Samuel Bowles and Co. of Springfield, Massachusetts, came with a price tag ranging from 75 cents to $6.50. [14] This new industry added jobs and bolstered the northern economy.

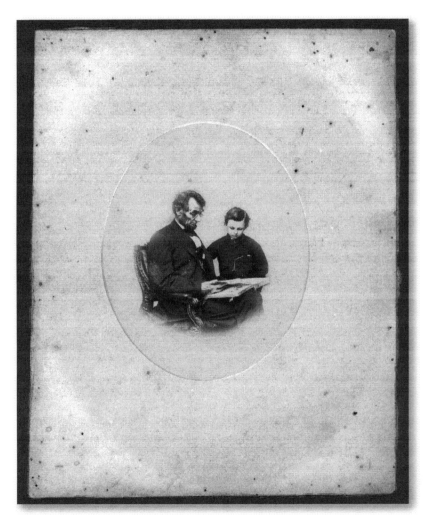

On February 9, 1864, President Abraham Lincoln and his son Tad visited the Brady Gallery in Washington, D.C. where this photo was taken of them looking at a photo album. According to the description on the Library of Congress website, this photo is the only close-up of Lincoln wearing glasses.

CHAPTER 3

Revenue Stamps

If you own a card photograph from the Civil War era, turn it over. On the back you may find a revenue stamp. The United States government financed a portion of the war using tax stamps. The United States Treasury Department, under an Act from Congress, issued legislation on 1 August 1864 that required photographers to place tax stamps on the backs of images they sold to customers and to provide their initials and the date. In reality, few photographers fully complied with the latter requirements.

The stamps themselves provide details on the cost of these card portraits. A 2 cent stamp was applied to photographs costing less than 25 cents and images worth between 25 and 50 cents bore a 3 cent stamp. Photographs that cost from 50 cents to $1.00 bore 5 cent stamps. Tax stamps could be combined for added value. A modification to the law in March 1865 lowered the tax on images that cost less than 10 cents to 1 cent each. The government repealed the law on 1 August 1866.[15]

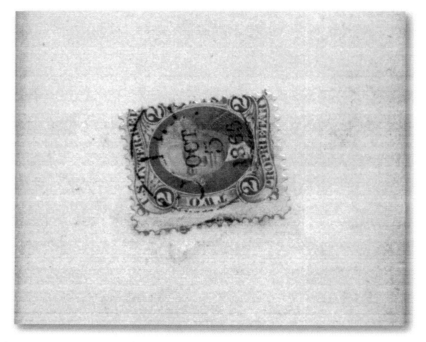

The photographer used an ink stamp to place a specific date on this photo, October 5, 1865. Two cent stamps were either blue or orange. This one is orange. This image would have cost less than 25 cents.

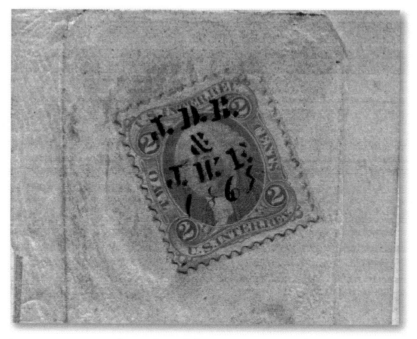

In this instance, two sets of initials and the year appear on the reverse. This stamp is also orange. It is stamped 1865.

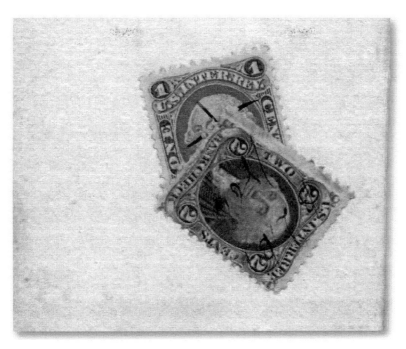

The photographer combined two different denominations on this photograph. The presence of the one cent stamp dates this image between March 1865 and 1 August 1866 when that denomination stamp was available. 1 cent red stamps marked playing cards are the rarest revenue stamp.

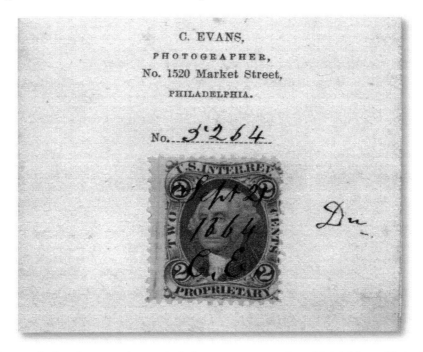

On this card, the photographer included a negative number. It's highly unlikely that the negatives still exist. Charles Evans dated the stamp Sept 21 1864 and included his initials.

This photograph bears a green 3 cent stamp.

From
C. COLE'S
82 Washington St.
Roxbury, Mass.

Additional copies from the plate from which
this picture was taken, can be had if desired.

Along the bottom of this stamp is "playing cards." It wasn't intended to be used on photographs, but the scarcity of stamps during the summer of 1866 led to their use.

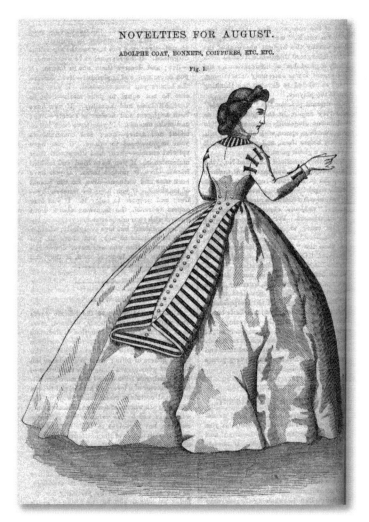

NOVELTIES FOR AUGUST.

ADOLPHE COAT, BONNETS, COIFFURES, ETC. ETC.

Fig. 1.

This Adolphe Coat was considered a new fashion for August 1864. Godey's Lady's Book. August 1864. This image also appeared in the August 1864 issue of Peterson's Magazine along with a seven piece pattern so that readers could make it.

CHAPTER 4

Women's Clothing

There were several magazines published specifically for women during the Civil War. One of the most popular was *Godey's Lady's Book* edited by Mrs. Sarah J. Hale and Louis A. Godey. By 1860, the magazine had over 150,000 subscribers who paid $3.00 annually for 12 monthly issues. Godey published the magazine from 1830-1878 with Hale as editor from 1837-1877. In 1877, Godey sold the magazine to another publisher who continued printing it until 1898. In each issue, women found colored fashion plates showing the latest styles, directions for making household decorative items, musical pieces and literary selections. While most of the articles were written by men, editor Sarah Josepha Hale published three issues that included articles penned only by women.

The first few pages of each issue portrayed engravings and a double-page color tinted fashion spread. Color plates and black and white engravings showed examples of clothing available in fashionable France and in specific New York establishments. Directions on how to home sew a dress or other garment appeared in every issue. Women who sought information on fashionable dress consulted issues of this magazine and made their own outfits modeled after those shown.

Peterson's Magazine was a direct competitor to *Godey's*. *Peterson's* began publication in 1842 and in the 1860s bragged that it was the least expensive magazine and, for a time, had more subscribers than *Godey's*. *Peterson's* used

a similar format to entertain and educate readers – fashion plates and notes, stories, and instructions on home handiwork.

During the Civil War, a nationwide shortage of fabric arose when northern factories were unable to obtain southern cotton. Women in the South had limited access to factory-made fabric so they often re-used fabric or learned to weave their own. Hats could be made from **ryestraw** and **palmetto** as was some jewelry. In the North, women re-made clothing, but they also bought imported goods. At the 1864 New York Sanitary Fair, individuals pledged to buy American rather than purchase imported fabrics. The largest fabric printing company in the world was located in tiny Rhode Island – the A. & W. Sprague Co., run by Amasa Sprague and his brother William. In the financial crisis that followed the war, Sprague went bankrupt.

On the frontier, homespun dresses or remade simple garments suited the hard work that women faced every day. Even in rural areas, women maintained an interest in current fashion trends. While fashion plate styles weren't necessarily suitable for everyday attire, women sought to copy current fashions in accessories such as hats and collars, adding decorative elements to plainly styled dresses. Younger women tended to wear the latest designs advertised in color plates and fashion engravings in the magazines, but older women were often less invested in the most up-to-date styles.

As early as 1860, Ellen Louise Demorest, known as Madame Demorest, developed a method to print clothing patterns on tissue paper and offered them for sale. Madame Demorest and her husband, William Jennings Demorest, established a company to manufacture and distribute those patterns. She also published a successful women's fashion magazine, *Demorest's Illustrated Monthly*. Ebenezer Butterick, a tailor and his wife, competed with their own line of tissue paper patterns which they began offering in 1863.

There were sewing machines available in the 1860s from various manufacturers including Singer and Merrow and even pattern maker Mrs. Demorest. Most December issues of *Godey's* suggested a sewing machine as the perfect gift for women. In January 1863, *Godey's* included an advertisement for the Demorest machine stating that women could use it to sew on the most delicate fabrics. Interested parties could order the machine directly from her New York address for $5.00.

Advertisement Godey's Lady's Book. January 1864.

A wide range of fabrics for women's clothing was available from colorful silks and taffeta to cottons woven in small geometric, abstract or floral designs. Elaborately pleated dresses involved more fabric and indicated economic status as did large patterns on fabric. Large designs required the seamstress to match the print thus wasting fabric.

It's difficult to gauge clothing colors in nineteenth-century photographs unless they've been hand-colored. Popular hues for women's apparel in the 1860s ranged from tan, shades of brown and natural colors to brighter shades. For instance, during Italy's struggle for independence in the early 1860s red was a common color in the United States, an expression of support for the revolutionaries.

You wouldn't think that there was a relationship between medical research and color dyes, but it's true. Until the late 1850s, all fabric dyes were derived from natural sources, but in 1856, Englishman William Perkins was experimenting with quinine (an anti-malaria drug). His experiment failed, but he serendipitously discovered a synthetic purple, which became known as aniline purple and later mauve. Perkins patented his process and opened a dyeworks to produce the synthetic substance. Other non-organic dye was soon

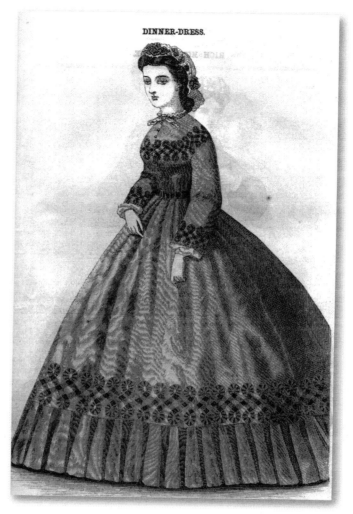

Fashion notes from the January 1864 issue of Godey's Lady's Book. "An apple-green silk trimmed with one deep box-plaited ruffle. Above that, the trimming is formed of ribbon or velvet." Godey's also included an enlarged view of the trim in the same issue.

to become available. Brilliant pinks – magenta and **solferino** – named after Italian towns, were widely used. [16]

Patterned fabrics were also available. Striped fabric was often used for walking dresses. **Tattersall**, a checked patterned fabric, was available in browns and tan. Also common were alpaca fleece dresses (derived from llamas) with

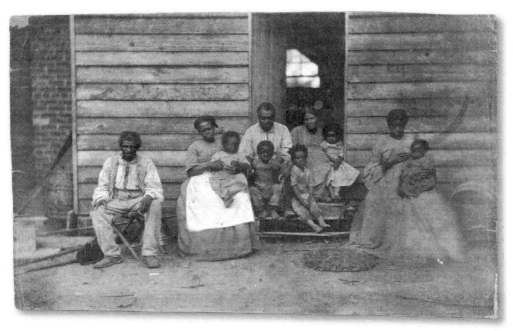

Family of Slaves at the Gaines House taken in either Washington, D.C. or Hampton, Virginia. George Harper Houghton, Photographer 1861/2.

African American women usually wore clothing appropriate for the time period – dresses or skirts and shirts. According to the PBS series Slavery and the Making of America, slave women made pantalettes, an undergarment like a pant that ended at the knee. These were worn under skirts. Cloths that wrapped around the head offered protection from the weather and also lice.[17] Laws required slaves to cover their heads with scarves.

contrasting decorative elements; dark on light and white on black. It's easy to think that our ancestors dressed in shades of black and white, but actually a wide range of colors are depicted in photographs. For instance, the January 1864 issue of *Godey's Lady's Book* featured an engraving of an apple-green silk dinner dress trimmed with velvet.

Tips for Dating Fashion

Dating fashion in photographs is all about paying attention to the details. From collar to cuffs and from hats to shoes, a wide variety of apparel styles appeared

in the 1860s. However, there are some general design elements common to the period.

Collars

While many different collars styles were available, they were usually less than an inch in width. Small round collars (like today's Peter Pan collar), narrow stand-up collars, or turned down collars with no ends were common. Lace was still a popular option as was a solid white fabric collar. Older women often wore dark colored collars. These collars were not attached to the dresses. Women changed collars to 'freshen up' the dress between washings.

Bodices

Bodices fastened with hooks and eyes in the front. Some had a v-shape at the waist, while others had a fan shaped front. A decorative piece, known as a fichu, was made out of thin fabric and accented the bodice. It was worn around the

How to Dress for a Photograph

Let me offer a few words of advice touching dress. Orange color for certain optical reasons is photographically, black; blue is white; other shades or tone of color are proportionally darker or ligher [sic] as they contain more or less of these colors. The progressive scale of photographic color commences with the highest. The others stand thus: white, light, blue, violet, pink, mauve, dark blue, lemon, blue-green, leather brown, drab, cerise, Magenta, yellow green, dark brown, purple, red, amber, moroon [sic], orange, dead black. Complexion has to be much considered in connection with dress. Blondes can wear much lighter colors than brunettes. The latter always present better pictures in dark dresses, but neither look well in positive white. Violent contrasts of color should be especially guarded against. [18]

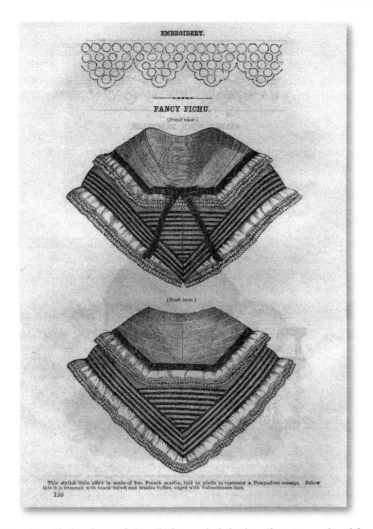

*This was simply called a fancy fichu. "This stylish little affair, is made of fine French muslin, laid in plaits to represent a pompadour corsage. Below this it is trimmed with black velvet and muslin ruffles, edged with **Valenciennes** lace." Godey's Lady's Book. February 1864.*

neck and shoulders. There were different styles and names for various shaped fichus and *Godey's* often kept its readers informed of the changes in bodice and fichu designs.

Women defined their waists using belts or "girdles" (a type of belt). Dresses highlighted in the 1864 issues of *Godey's Lady's Book* featured wide belts accented with oversize buckles made of mother of pearl, enamel, steel,

A Girdle, aka a belt. Godey's Lady's book. February 1864. "It is made of black silk, and bound on each edge with scarlet velvet. Through the entre is a leather band, studded with steel knobs. The bow is of black silk, bound with scarlet velvet."

jet (fossilized coal or black glass), or gilded metal. Dresses often came with waistlines above the natural waist and shorter bodices. Later in the war, trim near the shoulders accented bodices. Horizontal (not vertical) trim was the norm and consisted of a narrow braid, ribbons or buttons. Piping was common at the arm opening.

Sleeves

In the early 1860s, sleeves could be wide, flaring at the elbow. According to Joan Severa, in *Dressed for the Photographer: Ordinary Americans & Fashions 1840-1900*, this type of sleeve was worn over an undersleeve and only in summer.[19] Undersleeves of white muslin were worn under the lower half of the full sleeve and were trimmed with lace or embroidery. Undersleeves tied around the arm at the elbow. In summer months or for evening dress, short sleeves were acceptable. The majority of sleeves were gathered at the wrist.

Two undersleeves from Godey's Lady's Book, September 1864. The upper band wraps around the arm with the lace at the wrist.

The Spring Fashions

The Sleeve-The sleeve is made in every variety or form, from the loose flowing sleeve to the tight fitting jacket sleeve. A sleeve, with a lozenge shaped opening, though which the undersleeve appears, is a pretty novelty and when the design is carried out in the waist, and an opening of the same shape on each side of gored front gives to view the muslin or lace insertion arranged underneath, the effect is very elegant and stylish.

Augusta Chronicle. *April 21, 1863.*

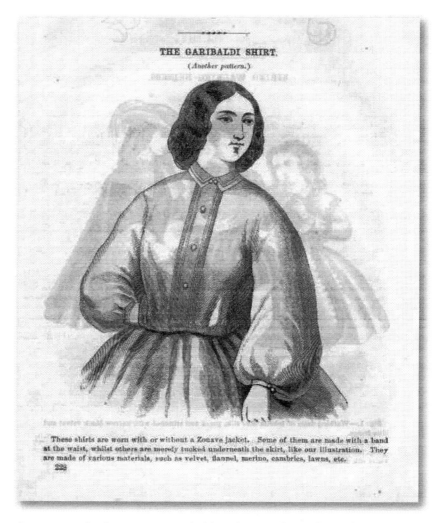

THE GARIBALDI SHIRT.
(*Another pattern.*)

These shirts are worn with or without a Zouave jacket. Some of them are made with a band at the waist, whilst others are merely tucked underneath the skirt, like our illustration. They are made of various materials, such as velvet, flannel, merino, cambrics, lawns, etc.

These shirts were also known as Garibaldi jackets and usually had military-style trimmings. The name derives from Italian hero Giuseppe Garibaldi, who fought for Italian independence from Austria in 1860. It is also possible that the mid-nineteenth century fashion icon Empress Eugénie de Montijo of France introduced the style in the early 1860s. The Empress influenced women's fashions throughout the 1850s and 1860s.

Shirts

For the most part, skirts and bodices matched in fabric and patterns. One exception was a plain skirt worn with a Garibaldi-style shirt. The March 1862 *Godey's Lady's Book* issue featured this description of the shirt: "It hangs loosely around the body, comes up high in the neck, with turning colar [sic] and fastens rightly around the waist and wrists. From its appearance we judge it to be a very pleasant dress for summer wear."[20]

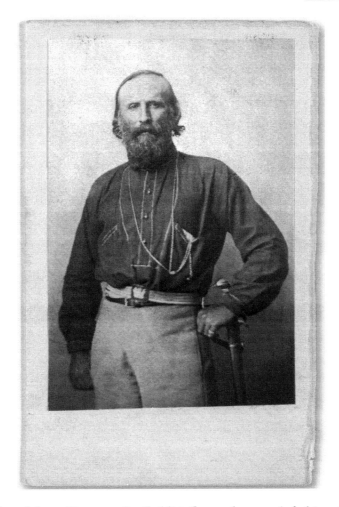

Italian freedom fighter Giuseppe Garibaldi influenced women's fashion choices.

Not everyone was happy with women's apparel that resembled men's clothing, including shirts. An article in the *Sandusky* (Ohio) *Register* criticized the style.

"We don't like it, nice as it is, and all because it heralds to the world, and seems to fancy the notice, too, that the ladies, after having got our "unmentionables" [i.e. pants] from us—us, the lords of creation, we mean—have now appropriated to their use a still more unmentionable garment—the shirt! and "it's all the rage in Paris. Plaited bosom, collar, neck-tie, cuffs and all—they have got it all—A lady in a man's shirt! Just think of it!—no, no, you needn't either. It's quite too bad to think about. I must go on madam; it's all the rage, but better do it without thought… The

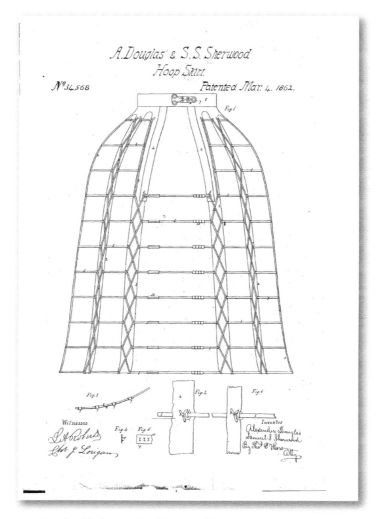

Patent drawing for the "skeleton skirt." United States Patent, 34, 568. Improvement in Ladies' Skirts, March 4, 1862.

"hat" (referring to the change from bonnets to hats), the "pants" [a reference to reform wear."] and now the shirt! My stars, what next?"[21]

Skirts

Skirts were generally gathered or worn pleated and full in the front. Hemlines fell to just a few inches off the ground. This was also the era of the hoop skirt. Skirt frames or supports existed before the Civil War, but the 1860s saw the introduction of a number of different styles. The United States Patent Office issued many "improvements to the hoop skirt" in the 1860s. In 1859, a patent was granted for an apparatus called the "skeleton skirt" because of the elaborate

frame that looked like a skeleton. According to period newspapers, the mid-nineteenth century hoop skirt originated in France and was supposedly based on the design of a chicken coop! An 1862 article blamed the Empress Eugenie for the hoop and other fashion "foibles." In sarcastic language, the author said of Empress Eugenie: "The hoop skirt was one of her caprices, and a most beneficial one too. It has furnished employment to thousands and thousands; enjoyment to millions and millions and inconvenience to billions and billions. But no living woman has ever denounced it, so, we repeat the hoop skirt is a benefit."[22]

The first hoop skirt factory in the United States was established in New York City in 1859 and employed over a thousand women to make the frames. Hoop skirts weren't new in the 1860s. Various shapes and types of hoop skirts dated to the sixteenth century. But the basic construction remained the same.

Lamb Knitting Machine

The LAMB KNITTING MACHINE Co. are prepared to furnish the best Family Knitting Machine extant. Their Machine is adapted to knitting a great variety of articles such as Stockings, Mittens, Gloves, Leggings, Afghans, Shawls, Nubias, Breakfast Capes, Jackets, Wrappers, Hoods, Undersleeves, Drawers, Comforters, Smoking and Skating Cape, Neck-Ties, Scarfs, Suspenders, Lamp Wicks, Cords, & e; in fact the variety of articles that may be produced is only limited by the skill of the operator. The Machine narrows and widens by varying the number of loops or knits any desired size without removing the needles from four loops, forming a cord, up to it's full capacity. Knits tubular, double or flat with selvedge, turns the heel and narrows off the toe complete; it is simple and without the least knowledge of machines a woman can learn to operate it from the Book of Instructions. It knits one yard plain work in ten minutes pair socks in half an hour.

A woman can earn with it from $2 to $3 per day.

Springfield Republican. *October 12, 1865.*

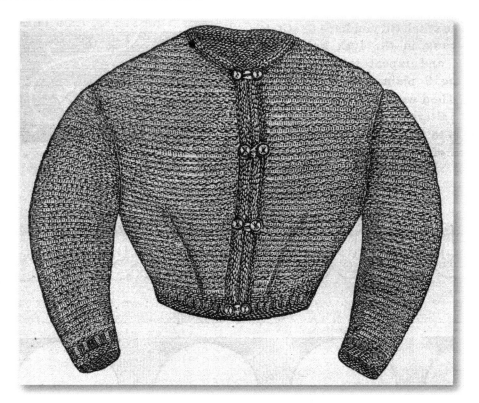

Sweater jacket pattern. Godey's Lady's book. October 1864.

A frame made from bone, rope, nylon or metal was covered with a light fabric. The main part of the dress was worn over the frame and covering.

In the mid-nineteenth century, factories and reform schools turned out thousands of frames each year. Wages for this work were low. Workers who produced hoop skirts were among those who participated in the November 1863 labor strikes in New York. Those who made hoop skirts (paid 50 cents per day) and slides (an unidentified task, but appears to be a device and paid 12 cents per dozen) wanted higher wages. [23]

Hoop skirts were worn in the North and the South. One newspaper reported that women in the South paid $55 for a hoop skirt in 1864.[24]

Civil War era newspapers frequently published stories of accidents caused by hoops. For instance, one woman skating in a hoop fell. When her companion tried to assist her, his foot caught in the hoop and he fell and injured his shoulder. Another woman was dragged through the streets when her hoop caught on the step of a buggy. She survived, but others died in similar

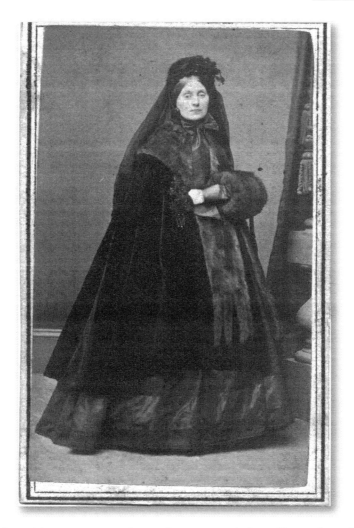

Unidentified wealthy woman in a long velvet coat with fur collar and muff. Her hat has a long veil. Photo by S. J. & C.W. Hallett, New York City.

accidents as a direct result of this fashion. Some women tried to shoplift or smuggle goods by hiding the objects in their full skirts.[25]

Outerwear

A diversity of outerwear was worn in both summer and winter. Patterned shawls, wide-hemmed sacque coats and jackets appear in photographs. Three-quarter length capes with or without arm openings were common. Jackets were fashioned with wide bottom edges or were made as short boleros or loose coats called **paletots**.

Here's a side view of a snood. Tintype of an unidentified young woman.

Hair

Empress Eugenie also set the standard for women's hair. Her fashion followers wore a center part with hair rolled up on the sides. Age, fashion sense and personality all influenced how women styled their hair. Not all women had long hair; shorter hair was in style for girls and young women, as were ringlets and long sausage curls that accented the face. Snoods, a mesh net, can often be seen in photographs. A ribbon worn at the crown of the head makes it easy to identify a snood. These mesh nets were often worn outside without a hat.

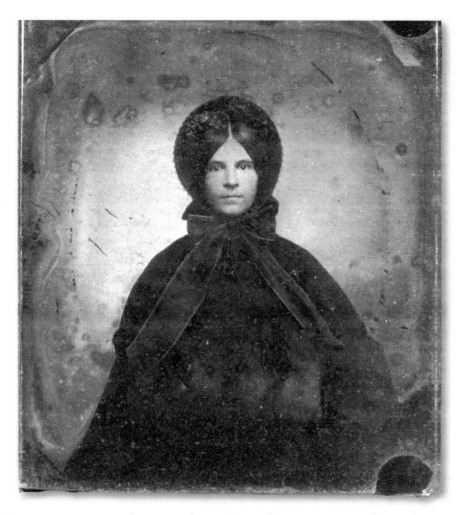

Woman wearing spoon bonnet and cape. Spoon bonnets were popular in the early 1860s.

Hats and Bonnets

Throughout the 1860s, bonnets were small and worn at the back of the head. Faces were framed rather than shielded by the bonnet. High-crowned spoon bonnets (so called because of the high brim), heart shaped bonnets and short brimmed Fanchon style bonnets were all popular. Small hats were just beginning to replace bonnets. At home, women wore **day caps**, muslin caps meant for indoor use and worn under bonnets.

Gallery of Images

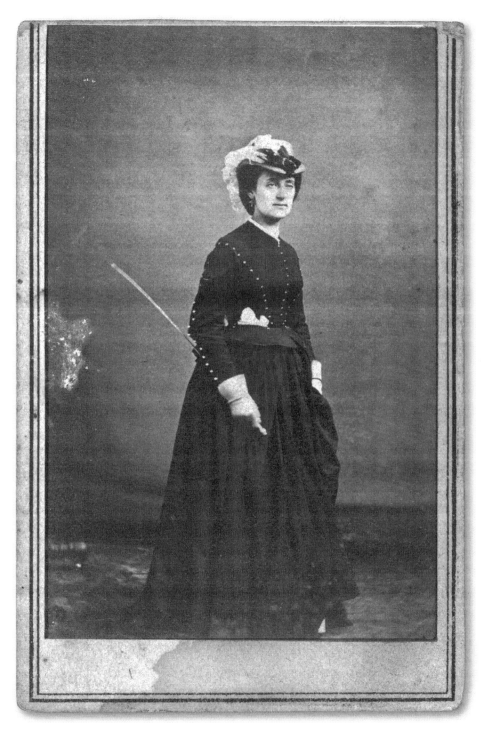

This unidentified woman wears clothing meant for horseback riding. She is holding a riding crop. Riding styles had fitted jackets, long sleeves and small hats. Identified as possibly Emma Cochran.

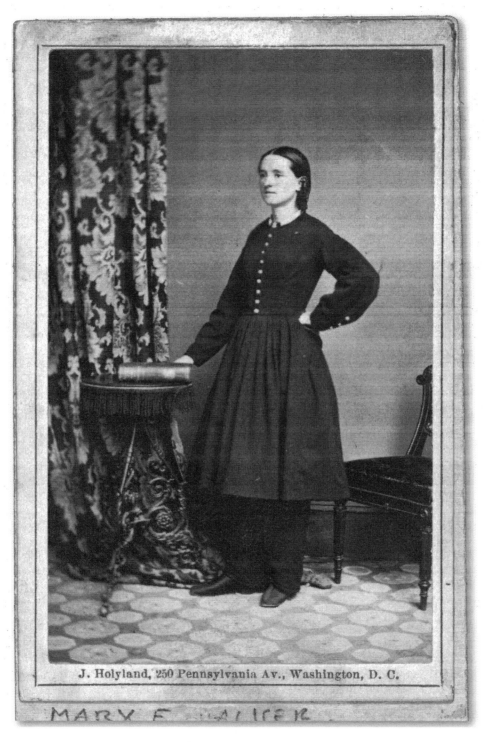

J. Holyland, 250 Pennsylvania Av., Washington, D. C.

MARY E. WALKER

Civil War surgeon Mary E. Walker wears long pants beneath her dress. This attire was usually referred to as reform dress, a nod to the women's rights activists who supported it. Her pants and shorter skirt with no hoops would be practical on the battlefield. Photographer John J. Holyland. Image taken between 1860 and 1870.

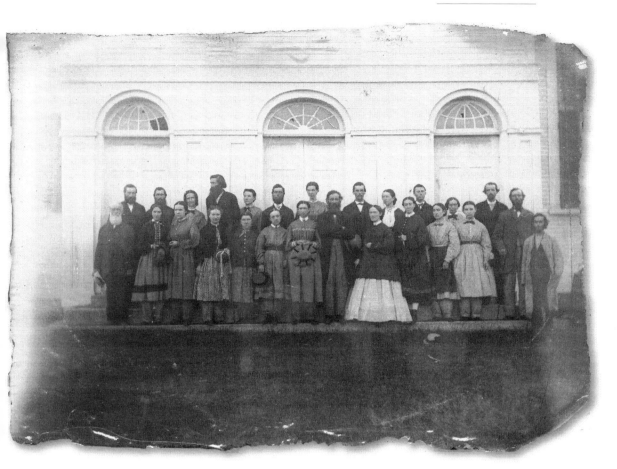

A group of dress reformers, taken in Worcester, Massachusetts. Card on the back indicates T.K. Earle, Worcester. An Edward Earle built The Worcester Water Cure for a Dr. Seth Rogers. The short dresses were considered healthy. The Water Cure advocated a good diet and healthy exercise.

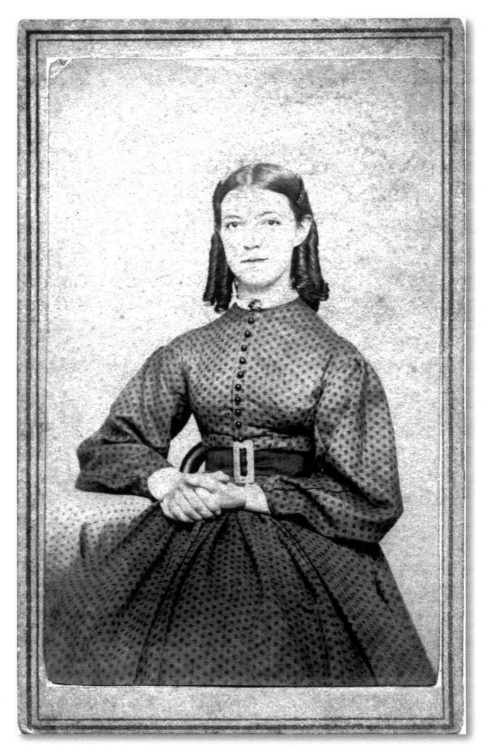

This unidentified woman wears a cotton dress in a small patterned fabric with a wide belt at the waist and a narrow band collar. She wears her hair pulled back and long sausage curls, a clue that she's probably still a young woman. Early 1860s.

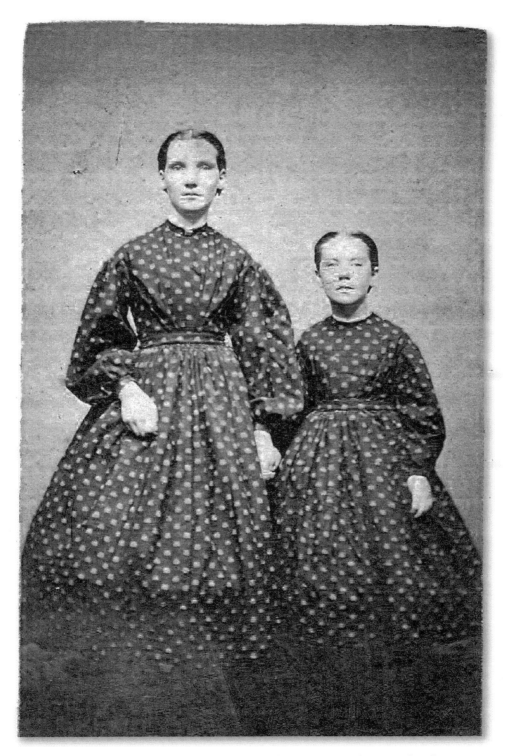

Unidentified mother and daughter in identical cotton print dresses. This design is similar to the dress in the previous photo. Note the shadow that shows the hoop under the mother's skirt. Early 1860s. Photographer H. G. Pearce, Providence, Rhode Island.

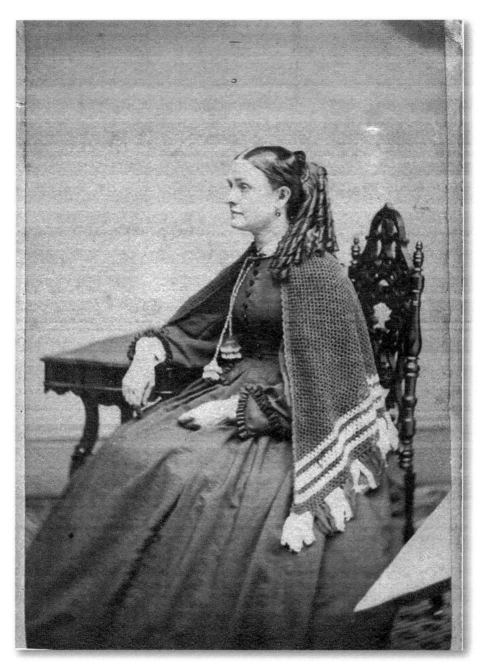

White undersleeves peek from beneath the sleeves in this image. The woman wears a hand-knit shawl draped over her shoulders. Her hair is simply arranged with rolls on the side of the head with long sausage curls. L. Thompson, photographer, Shetucket, Norwich, Connecticut. Early 1860s.

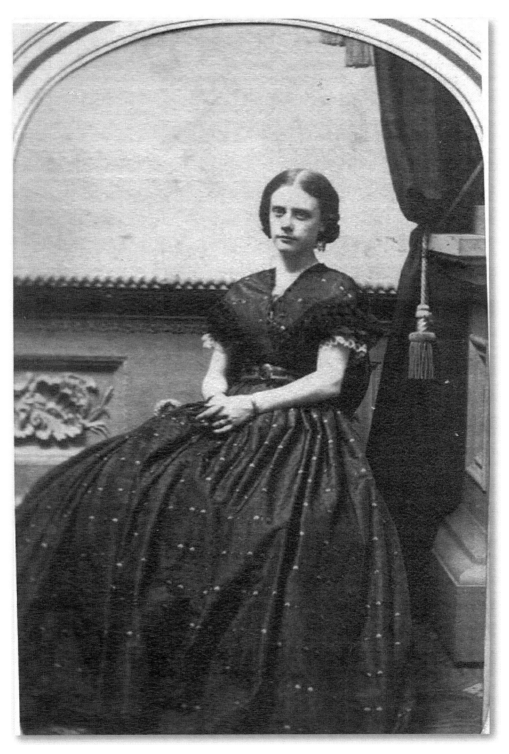

Unidentified woman in a short sleeved summer dress. 1860s.

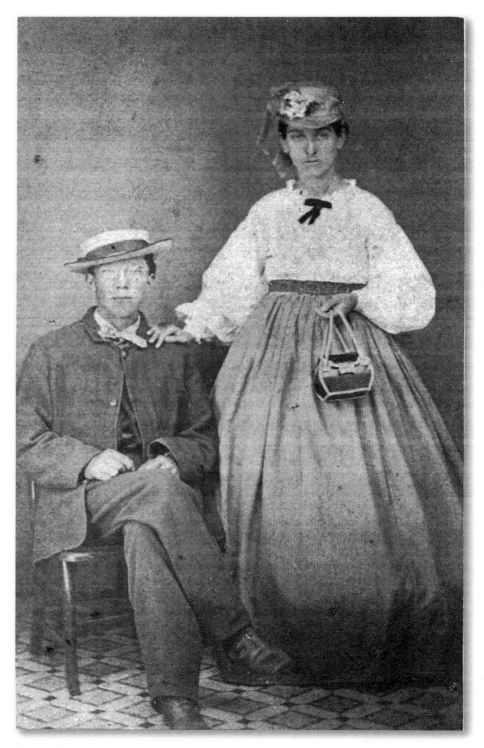

A lovely photo of a young couple. She wears a Garibaldi shirt, hoop skirt, and a small hat. She carries a pocketbook. Her companion wears a loose fitting **sack** *coat and a broad-brimmed flat crowned hat. J.B. Gibson, artistic photographer, Coastesville, Pennsylvania. Late 1860s.*

*Unidentified woman seated at a table. Photographer Nicholas Ghirardini, Providence, Rhode Island. Her striped silk dress has full **pagoda** sleeves and velvet trim with a round collar. She wears her hair over her ears with a braided coil low on the neck. Early 1860s.*

This unidentified woman's dress is in a tattersall check fabric. A small band collar encircles her neck. She wears her hair in a net. Early 1860s. Photographer, Scholfield, Westerly, Rhode Island.

An unidentified group portrait. Bundy & Williams, 314 & 326 Chapel St., New Haven, Connecticut. The women carry patterned shawls and wear small bonnets that just cover the crown of the head in the style of the 1860s. The woman on the far left wears a fanchon bonnet with the heart-shaped center. Bonnets featured wide silk ties worn in a large bow under the chin.

Accessories

+ Gloves were available in a variety of colors—yellow, blue, green, pink and shades of gray. They were made of solid fabric or leather but crocheted and knitted mitts (often fingerless) were common.

+ Jewelry Styles: cameos, velvet neck ribbons, tortoise shell combs, large drop earrings, circular or oval pins, hair jewelry and pocket watches

+ Fur cuffs on coats as well as muffs. These were made from ermine as well as white and dark rabbit fur.

+ Parasols and umbrellas

+ Handbags

+ Veils

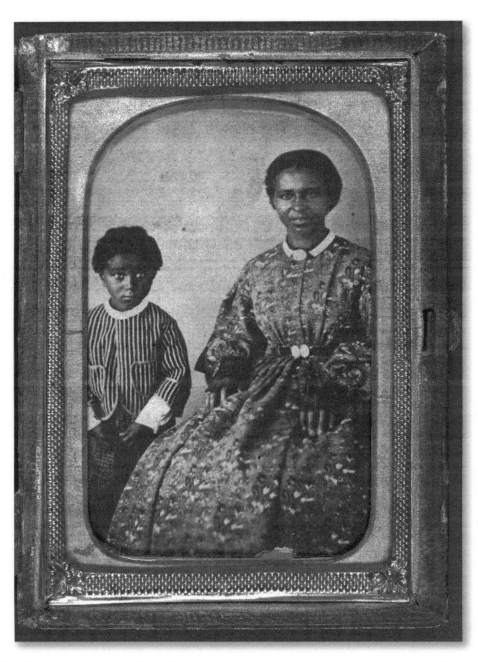

Unidentified woman and child in the1860s. The woman wears a print cotton dress with a small collar, while the boy wears striped jacket and plain pants.

CHAPTER 5

Children's Clothing

Children's apparel in the Civil War era depended on their age, their gender and their parents' economic status. Both *Godey's Lady's Book* and *Peterson's Magazine* included fashion plates showing children's clothing. Fashion notes in the magazines also offered advice for mothers on how to dress their children. However, the average child's wardrobe differed from what was promoted in women's magazines. Clothes for the majority of children were practical and didn't impede their playtime. Hand-me-downs were likely a part of most children's wardrobe.

According to *Slavery and the Making of America*, slave children wore little if any clothing until adolescence. Long shirts were worn by both boys and girls until they were old enough to dress like their adult counterparts. [26]

While wealthy families dressed their children like the fashion plates, complete with corsets for young girls, many families sought to find ways to make clothes that fit the family budget. Small overall patterned fabric could be sewn into outfits with little wasted cloth. These types of patterned fabrics had an advantage. They didn't have to be matched.

Babies of both genders wore long dresses featuring yokes and lace. These long dresses resembled present day christening style gowns, but they were meant for everyday wear.

Typical dress for babies. Godey's Lady's Book. April 1861.

Toddler girls wore dresses or skirts while their brothers wore either short pants and a shirt (buttoned to the pants at the waistband) or a long shirt with underwear similar to pantalettes. The latter was known as a Nankeen suit. Until around the age of 5, boys sometimes wore skirts decorated with military style trim. One style of long shirt, the French Blouse, was worn belted at the waist with underdrawers or short loose pants.

Unidentified boy. L.W. Cook, artist. Weymouth Landing, Massachusetts.

These outfits allowed small children the freedom to move and, I imagine, enabled mothers to toilet train their children. Distinguishing boys from girls can be a challenge when studying photos. There is a quick trick. Watch for the hair part. Mothers combed a side part into boys' hair while girls wore their hair parted down the center.

Unidentified boy. This style of suit was common for boys 7-12 years of age.
F. Kindler, Newport, R.I.

Also popular for boys from late toddlerhood to about age 7 was a suit with long pants and a short jacket that ended at the waist.

In the 1860s, children and some teens wore dresses with wide necklines and short sleeves. Skirts for young girls could be several inches off the floor – the older the girl, the longer the skirt. After age 9 or 10, girls dressed like

Unidentified boy. Most younger boys wore suits with ankle length pants, short jacket and a bow tie. C. Evans, Photographer. 1864-1866.

adults. Trim in black or white with wool in red, peach, cream, yellow or tan was common. Girls also wore pastels.

Pinafores were commonly worn for play and protected dresses while fancy aprons were considered a fashionable accessory.

By the teen years, girls dressed like their mothers and boys wore long pants and suits like their fathers.

Pinafore pattern. Godey's Lady's Book. 1860.

*Charles Edward Stewart and Della Leroy. As far as the owner can determine, this boy and girl were not related. He wears a **Knickerbocker** suit. Della's wide-necked dress was worn for Sundays or for a special event. Older boys wore their trousers belted at the waist and full length like their fathers. But some pre-teens wore shorter pants in the Knickerbocker style, loose with a band at the knee.*

Children's Dress

The dress of their children is a very important consideration for mothers. It is natural for all women to desire that their children should look becomingly dressed: but for this purpose health is often scarified. In selecting clothing for children, the age of the child must be taken into account, so that the organs of the body which are in greatest activity, should not be checked in their action by cold or undue pressure. In the very young child, the domestic organs are most actively at work, to supply the necessary nourishment for the rapidly developing body, but as the child gets older, the lungs and heart increase in activity, and require great protection. To guard against cold, the child should wear flannel, of varying thickness, according to the season of the year, next to the body, and fitting tolerably close, for, without this protection, the present styles of dress, causing the clothes to project away, leaves the body exposed to sudden chills. Under ordinary circumstances, the clothing should cover the whole chest up to the collar-bones. The head should be lightly covered so as to protect it from the sun, or sudden change of temperature; but it should never be covered with thick heavy material. Anything causing fullness or congestion about the head will very common act by sympathy, as it is called, on the stomach, and cause obstinate and violent vomiting. Again, the body or the extremities being chilled, will often produce congestion of the brain, headache, and convulsion; and this congestion, reacting on the stomach, will cause sickness. A great improvement has latterly been made in the dress of children by clothing the lower extremities, and thus diminishing the chances of cold. In the clothing of a child, it should be borne in mind whether the child has ever had any serious affection of any particular organ, as, if so, greater care should be given for its proper protection. No part of a children's dress should fit so tightly as to hinder the free use of the limbs and respiration. Anything that hinders the free use of the muscles, hinders growth, and promotes deformity. Stays or tight bands about the ribs compress them readily, as those bones are not fully formed, hence readily cause deformities and alter the natural and healthy position and action of the lungs, hear, liver, and stomach, and produce a tendency to disease in these organs.

Peterson's Magazine. *September 1864.*[27]

Gallery of Images

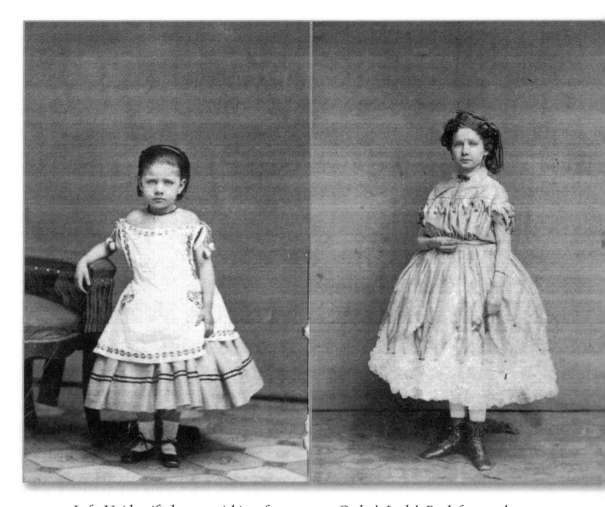

Left: Unidentified young girl in a fancy apron. Godey's Lady's Book frequently included embroidery patterns to add decorative elements to children's clothing. Photographer R. A. Miller. Boston, Massachusetts. Circa 1865.

Right: Unidentified girl wearing a "fancy hat." Circa 1865. She has beads sewn to the points on the dress bodice and sleeves. A photographer's brace is visible at her feet. The short sleeves and choice of fabric indicate it was taken in the summer.

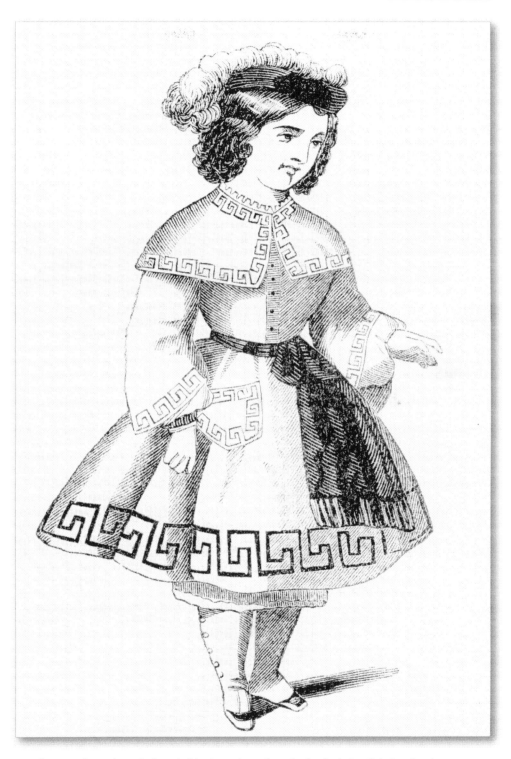

Buff pique dress, braided with black mohair braid. Godey's Lady's Book. August 1862.

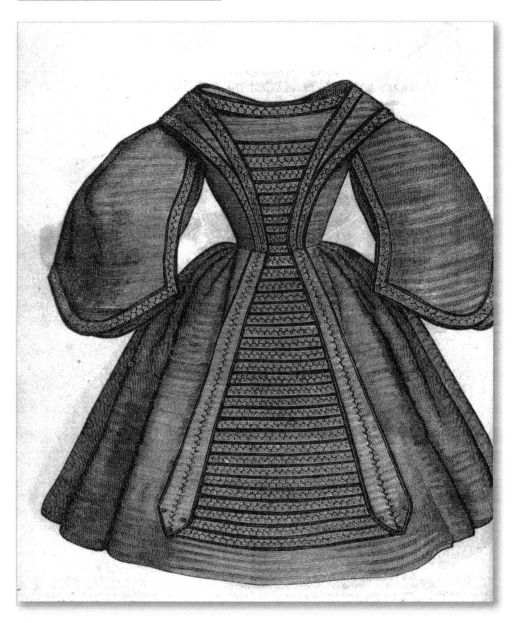

"Dress for a Miss." Godey's Lady's Book. 1864.

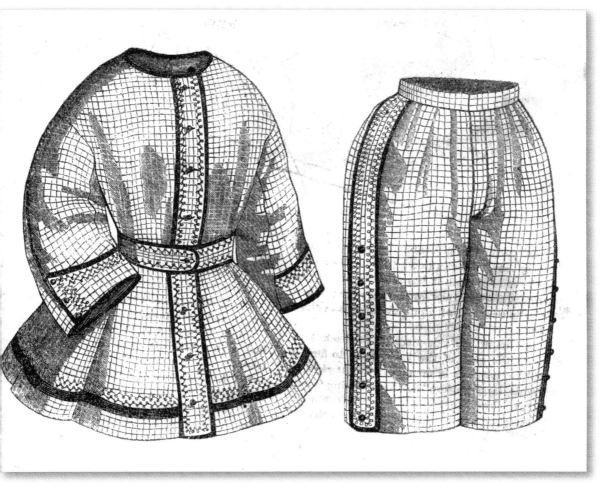

Garibaldi style suit for children. Godey's Lady's Book. April 1861.

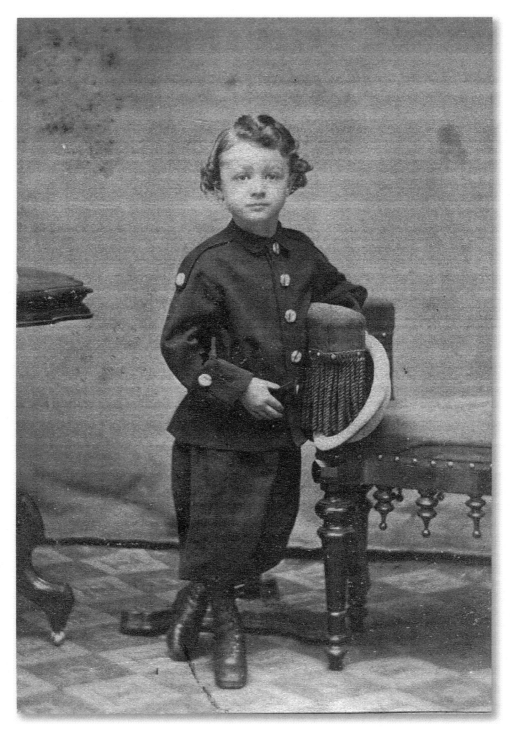

Unidentified boy in a suit. Circa 1866. Photographer L.A. Atwood. Cambridge, Vermont.

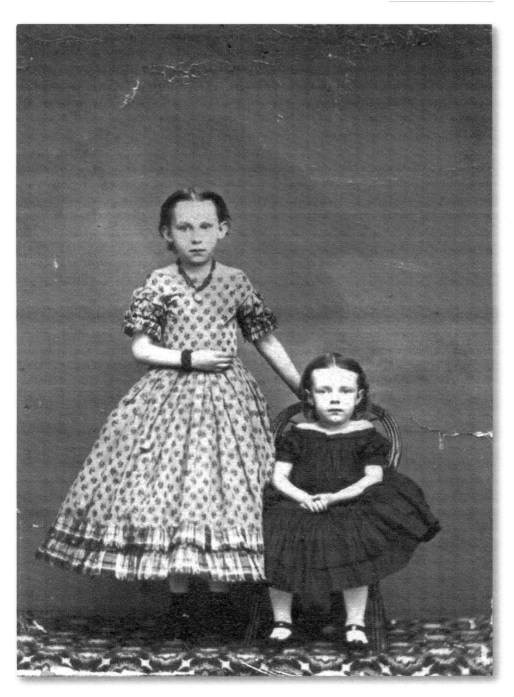

Two unidentified girls in wide-neck dresses.

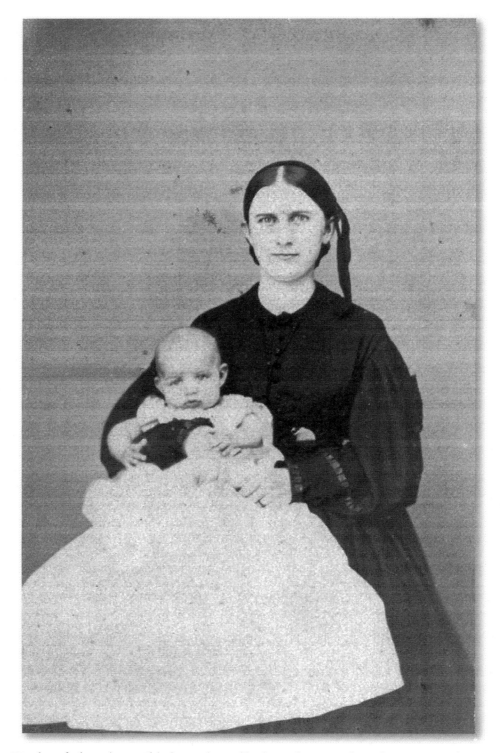

Unidentified mother and baby. Babies of both genders wore long dresses every day. The mother has her hair in a snood. A 2-cent revenue stamp on the back of this image dates it to 1864 -1866.

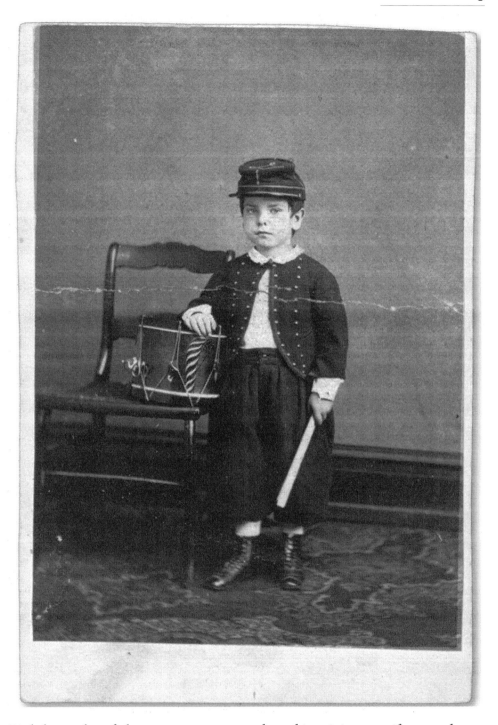

Little boys, whose fathers were away at war, dressed in miniature uniforms and played soldier. There was some reality in this attire. Small boys often served as drummer boys with the units. P.H. Martin, R.W. Addis, Photographer, 308 Penna. Avenue, Washington, D.C

Children's Fashions for February 1861. Godey's Lady's Book.

Children's Fashions August 1863, Godey's Lady's Book.

Fig. 1 – Dress of Eugenie blue poplin, trimmed on the skirt with alternate pieces of black and white ribbon sewed on slanting. Zouave trimmed with white ribbon, black velvet, and black drop buttons. The point is bound with black velvet. Leghorn hat, corded with black velvet, and trimmed with a blue feather rosette.

Fig. 2 – Dress of black and white poplin, trimmed with alternate quiltings of scarlet and black ribbon, half the point being of one color and half of the other. Wide sash of scarlet, black, and white ribbon. **Guimpe** and sleeves of white muslin, trimmed with muslin **ruchings**.

Fig. 3 – Dress of white pique, made square on the neck, and with **bretelles**. It is braided with scarlet mohair braid.

Fig. 4 – Suit of fine gray cloth, trimmed with a darker shad. Scarlet necktie. Polish boots, with scarlet tassels.

Fig. 5 – Black poplin blouse, trimmed with blue velvet, and confined at the waist with a blue silk cord and tassel. Black velvet cap, trimmed with blue velvet and a white wing. Polish boots, bound with blue velvet, and trimmed with blue chenille tassels.

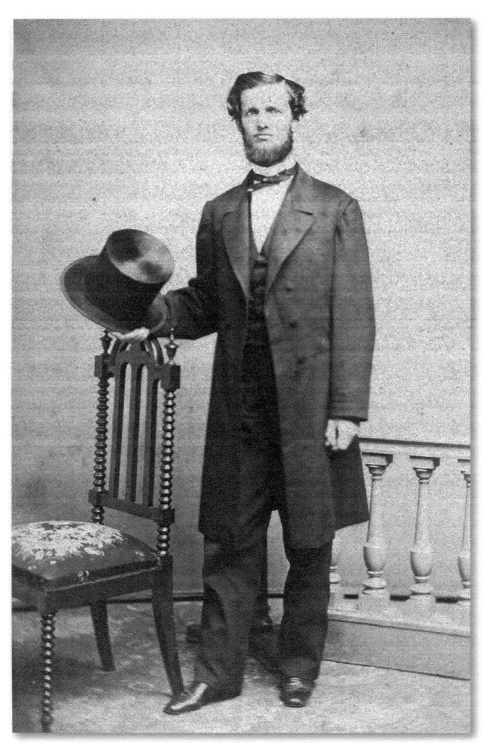

Unidentified man in a long frock coat holding a stovepipe hat. The simple photo studio set-up consists of a balustrade and a chair. You can see the photographer's brace at his feet. 1860s.

CHAPTER 6

Men's Clothing

Throughout the mid to late-nineteenth century, the definition of a well-dressed man was his attire. Unlike women who often made their own clothes, men purchased their clothing ready-made or had them custom-made by a tailor. Businessmen, artists, and even laborers wore a standard outfit – pants, jacket, shirt, and tie – for their Sunday best. Sunday best was usually newer clothes, while well-worn attire was typical for work. Laborers wore work shirts and often covered their clothing with leather aprons.

Clothing worn by African American men depended on where they lived and their occupation. Slave laborers generally wore clothing made from linen or from coarse woolen broadcloth. African Americans working in businesses and houses, or living in non-slave states, wore clothing and fabrics in the common fashion. For additional information on slave clothing, see Dorothy Denneen Volo and James M. Volo's *Daily Life in Civil War America*.

Don't be surprised to see laborers dressed in a suit in family photos. In general, it's somewhat unusual to see a man in work attire in studio portraits. Sitters dressed their best and wanted to convey respectability in a picture.

Dating Men's Fashion

Jackets and Vests

Jackets were long frock coats, oversize sack coats or long morning coats in black. A frock coat was fitted through the upper body but flared in a wider bottom. These coats had velvet collars. Sack coats were loose fitting. Morning coats weren't generally worn by the average man. It was a style preferred by wealthy and powerful men. Fitted suits were another sign of economic status, and primarily worn by wealthy men. Coats and tails were worn for special events. By the mid-1860s, there were some jackets made with checked pattern fabric and those that had a narrower fit. Collared vests were the norm, with most men choosing to wear a shawl collared style.

Coats and trousers made of the same fabric were known as **ditto suits**. Most men, however, wore jackets and trousers made of different fabric.

Shirts and Collars

There were dress shirts and work shirts. In the 1860s, they were longer than the men's shirts of today. Dress shirts were white with a detachable collar. These collars were often made from printed paper so that they supposedly looked like silk, gingham or other fabrics. The per-collar cost in 1861 was 25 to 50 cents a dozen.[28] Work shirts had a placket opening at the neck and came in a variety of colors.

While older and more conservative men wore white shirts, that wasn't necessarily the case for younger men. In the 1860s, some young men wore embroidered shirts. In the nineteenth century, young men who rebelled against the white shirts and black frock coats worn by their fathers often sported embellished shirts. There were even outlandish printed shirts seen in England. Some of these shirts featured skulls and crossbones, snakes and other outrageous designs.[30]

Trousers

You won't see belts or zippers in Civil War photos. Zippers were a twentieth-century invention. According to the American Centuries website, trousers were made by a tailor but pants were bought ready-made.[31] Work pants had

Gray's Patent Molded Collars

Have now been before the public for nearly a year. They are universally pronounced the neatest and best fitting collars extant.

The upper edge presents a perfect curve, free from the angles noticed in all other collars.

The cravat causes no puckers on the inside of the turn-down collar.—They are AS SMOOTH INSIDE AS OUTSIDE, and therefore perfectly free and easy to the neck.

The Garotte Collar has a smooth and evenly finished edge on both sides.

These Collars are not simply flat pieces of paper cut in the form of a collar, but are MOLDED AND SHAPED TO FIT THE NECK.

They are made in "Novelty" (or turn down style) in every half size from 12 to 17 inches, and in "Eureka" (or Garrotte) from 13 to 17 inches; and packed in "solid sizes," in neat blue cartons, containing 100 each; also in smaller ones of 10 each—the latter a very handy package for Travelers, Army and Navy Officers. "[29]

a button fly while the buttons on the French fly found on dress slacks were hidden from view by a fabric covering.

Trousers were narrow and tube shaped with the back slightly longer than the front. Fabrics included **cassimere**, cotton jean or drill, available in gray, blue, black and tans as well as checks and stripes. Jeans and pants were also made from cotton. While a person could buy unbleached muslin for $1.00 a yard, the average cost of pants made from imported material was $25.00.[32]

Cravats, Neckties and Stocks

Men either wore neckties or cravats. Cravats were a starched piece of silk, reinforced with horse hair, which wrapped around the neck under the collar. They came in white or black. Neckties resembled those worn today except they were usually wide and short. A stock was a piece of silk worn wrapped around the neck under the collar. Stocks were common in the 1850s, but some men still wore them in the early 1860s.

There were ready-made and tied cravats and stocks, but newspaper stories declared them disdainful. These pre-tied items had a narrow band that fit underneath the collar and were either buttoned, buckled or tied in the back. Bandanas could be worn with work shirts. White ties were worn for weddings and evening events.

Flannel

Flannel was extremely popular for outer clothing and undergarments. An article in the *Augusta Chronicle* suggested wearing flannel year round. Many people believed in the health properties of wearing red flannel next to the skin. The fabric supposedly increased blood flow and kept people from feeling cold. Flannel fabrics came in solid colors or were woven in plaids or checks.

Hats

While some men still wore top hats, aka stovepipe hats like those favored by President Abraham Lincoln, a wide variety of smaller hats (brimmed and brimless), bowlers, derby style and caps were available. Styles ranged from **Eton caps** and felt bowlers to small straw hats for the summer months. These came with a ribbon known as Nattie's. Hats worn by workers differed from those worn by gentlemen. Work hats were made of soft felt or resembled caps with a small brim in the front.

Flannel

Flannel.—Flannel should be worn in the summer and winter, during the day, but should be taken off at night. In summer it allows the perspiration to pass off without condensing upon the skin, and prevents the evil effects of the rapid changes of temperature to which we are liable in our changeable climate, when out of doors. In winter, as a non-conductor of heat, it is a protection against the cold. At night the flannel jack or jersey should be exposed to a free current of air, and allowed thoroughly to dry; it should never be put in a heap of clothes by the bedside. Flannel is usually only worn over the chest and abdomen.[33]

Hair

Men wore their hair long on top during the Civil War years. Beards and mustaches began to be fashionable during the early 1860s, but most men were clean-shaven. One newspaper suggested that the popularity of mustaches and beards was linked to German immigration. Once men started wearing beards and mustaches, the business of providing shaves and the production of shaving brushes was adversely affected. Beards were popular in the West, because they were practical for the frontier, before they caught on in the East. During the Civil War, men suddenly grew all types of beards, and they kept them for a generation. General Ambrose Burnside lent his name to a style of whiskers, Burnsides (the term was later reversed to become *sideburns*). American icon Uncle Sam first appeared with a beard during the Civil War and still has one today.[34] Abraham Lincoln was the first – but not the last president – to wear a beard.

Accessories

+ Monogram pin
+ Cuff links
+ Watches with charms on the chain. Watch pockets became available.
+ Signet rings
+ Gloves
+ Walking sticks (whether or not they were a necessity)
+ Silk handkerchiefs

Gallery of Images

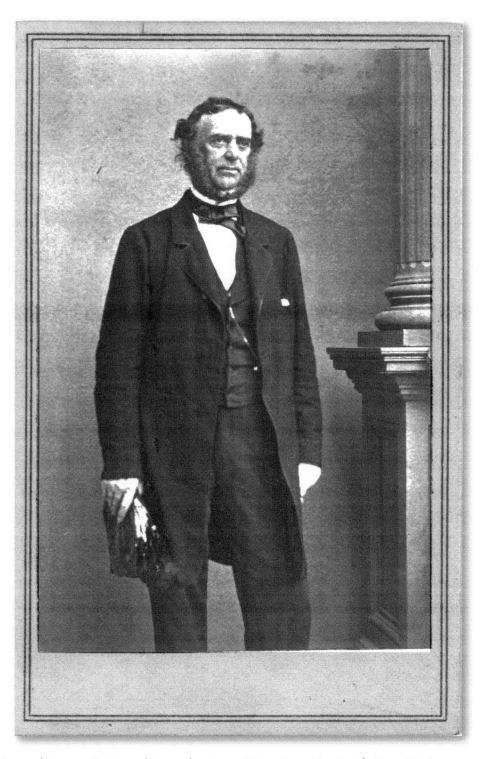

Samuel Francis DuPont (September 27, 1803 – June 23, 1865), E & H.T. Anthony, New York from photographic negative in Brady's National Portrait Gallery. He wears a silk stock wrapped under his collar. DuPont was a naval officer who eventually became a Rear Admiral.

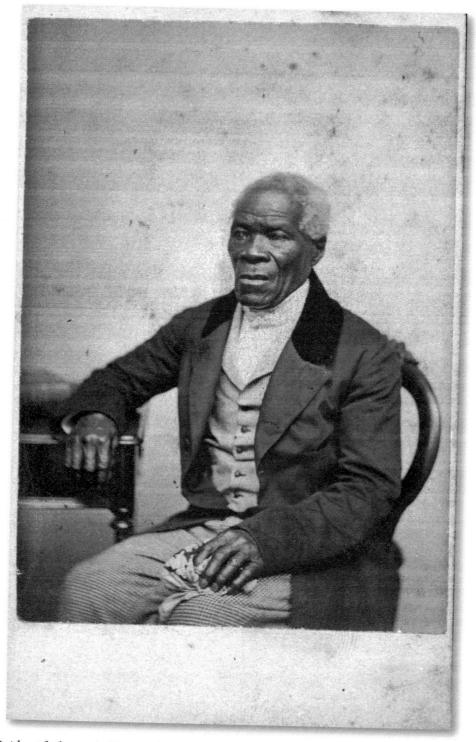

Unidentified man holding a cloth. Photographed by D. W. Bowdoin, Downing Block, Salem. 1860s.

Unidentified man in a heavy winter overcoat. The photographer's brace is visible at his feet. Photographer Gilchrist. Lowell, Massachusetts. 1864-1866.

George Augustus Sala (1828-?), British journalist and author. He wears an overcoat with a velvet collar and carries a top hat. Circa 1860.

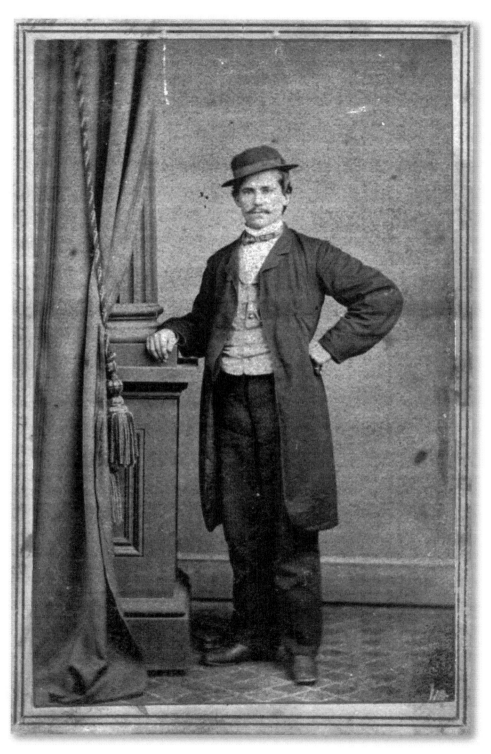

Unidentified man. He wears a long frock coat, vest, pants, a small bow tie and a jaunty hat. The studio arrangement is standard for the period – column, drapery, patterned floor covering and plain wall. A photographer's brace is visible at his feet. Photographer F.S. Keeler. Philadelphia, Pennsylvania. Circa 1864.

Capt. Goodrich's Jack. He wears a simple jacket. Notice how he smiles for his portrait. 1860s.

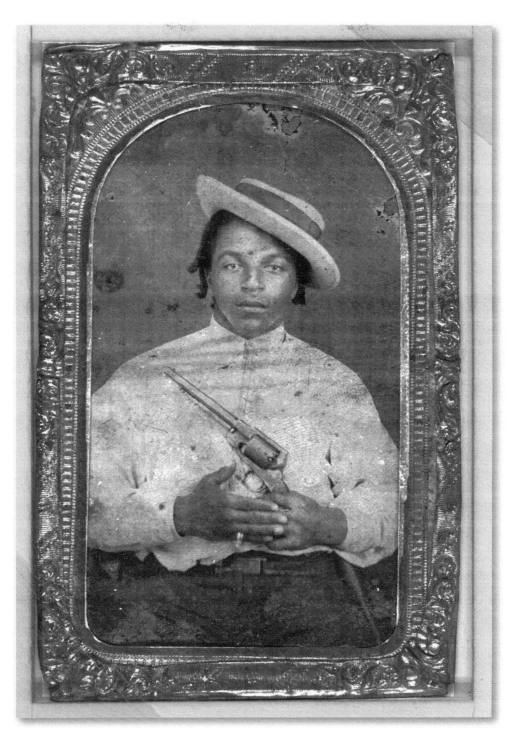

Tintype of unidentified civilian man holding Colt revolver. 1860s.

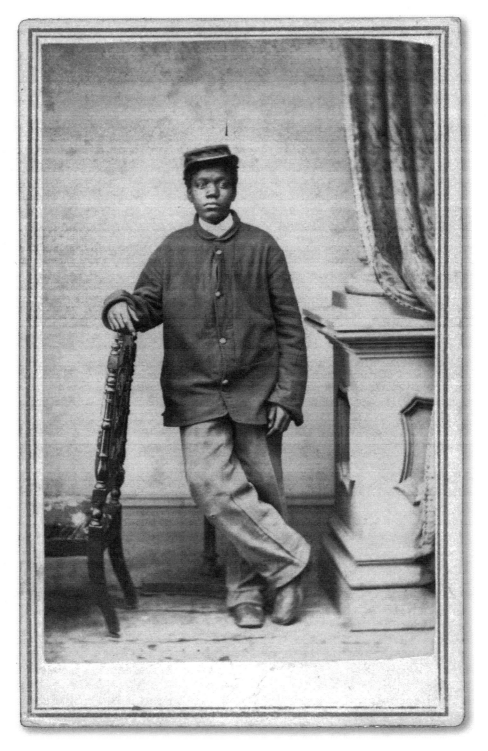

Henry Wright, private servant. Gayford & Speidel photographers, Rock Island Illinois. 1860s.

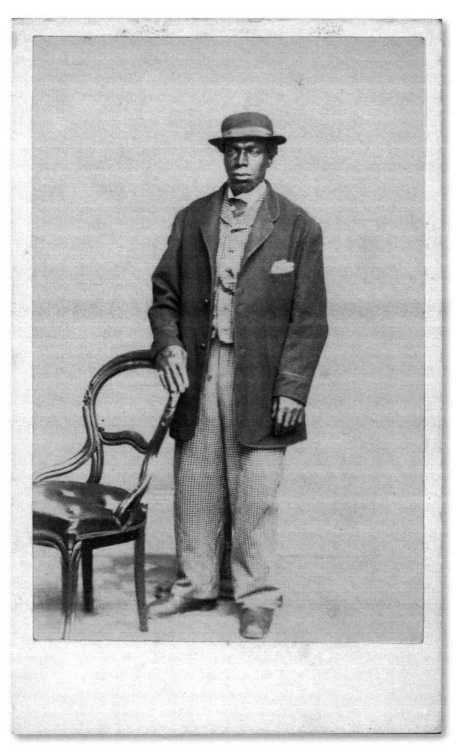

Old Abe. He wears a matching vest and pants in a checked fabric. 1860s.

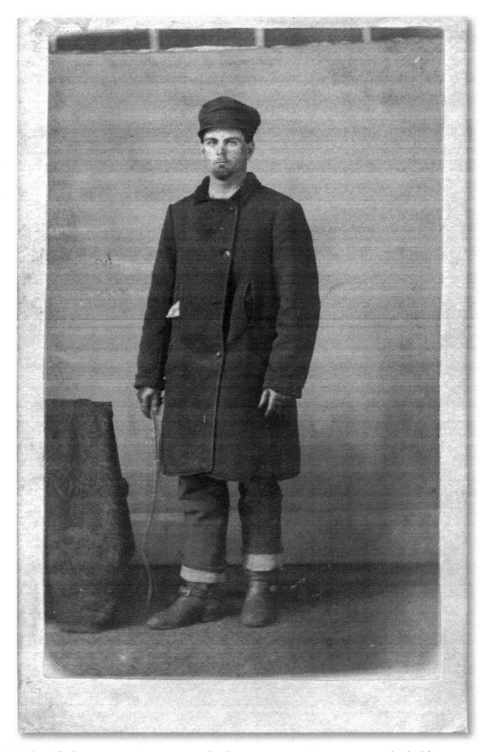

Unidentified man wearing jeans and a long overcoat. He appears to be holding a divining rod. N. Balwin, Wichita Kansas. Late 1860s.

This unidentified young man has short hair and a trimmed mustache. His suit and tie reflect styles common just after the war. Late 1860s.

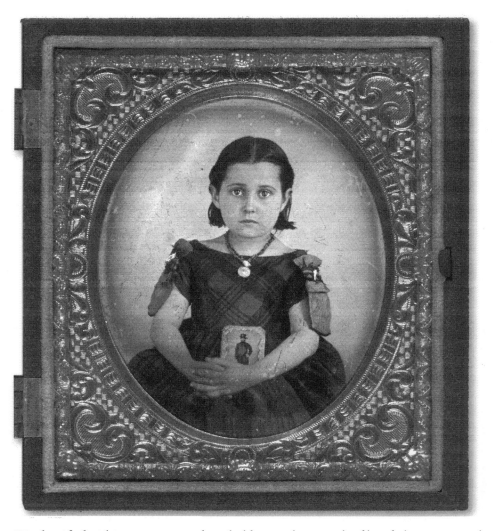

Unidentified girl in a mourning dress holding a photograph of her father wearing the uniform of a cavalryman with a sword. It was common practice to either photograph the deceased or to pose with photographs of the deceased.

CHAPTER 7

Mourning Rituals

The 1860s woman adhered to elaborate rituals for a period of mourning depending on her relationship to the deceased. But before thinking that this meant all black all the time, consider the spring fashions for mourning profiled in the March 1861 issue of the *New York Herald*. The magazine mentioned a wide range of appropriately dark fabrics such as barathea silk, crape, **bombazine**, Malta cloth, Norwich poplin, Japanese crape, pineapple silks, French poplins, black and white check grenadines and silks.[35]

Mourning colors included black and deep purple as well as white, but other colors were fashionable as well. One hat, sewn with lilac colored crape, was covered by a thin black fabric. Flowered edging with black lace accented the hat. Another head piece was made from white crape embroidered with white and black beads and flowers. White, mauve and royal purple were sometimes mixed with black to signify mourning. However, the magazine article ends with a statement about deep mourning being characterized by a lack of decoration and simple designs. The colors worn reflected the degree of mourning for the deceased – spouse, child, or distant relative.[36]

Stages of Mourning

The stages of mourning dictated a woman's attire. For instance, a woman in full mourning for a husband wore a black dress with dark collars and cuffs. Dark black fabric devoid of any gloss or shine was the style. Her hat was typically draped in black crape and a veil. According to Mary Brett in *Fashionable*

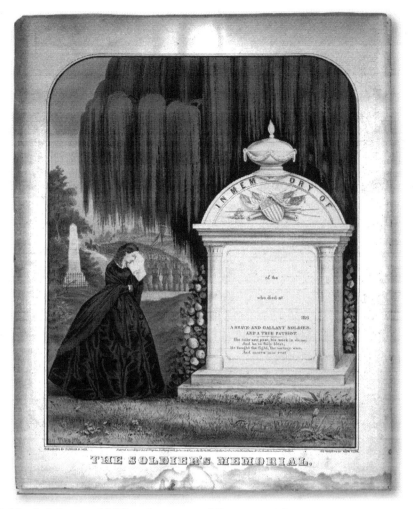

"The Soldier's Memorial." This Currier and Ives print, shows a woman wearing full mourning attire. The symbolism of the grave marker and the weeping willow often appear in mourning pieces. Blank spaces on the lithographic tombstone could be filled in by the grieving family. Published by Currier & Ives. Circa 1863.

Mourning Jewelry, Clothing and Customs, the dye used on the veil had a strong unpleasant odor.

Women were supposed to be entirely covered by the veil when in public. Mourning for one's husband lasted from eighteen months to two years. After the second year in the period, women moved into half mourning and were allowed to introduce gray, lavender, white, purple and mauve into their clothing.

Husbands mourned for three months to a year. During this period, men wore black armbands or a pin.[37]

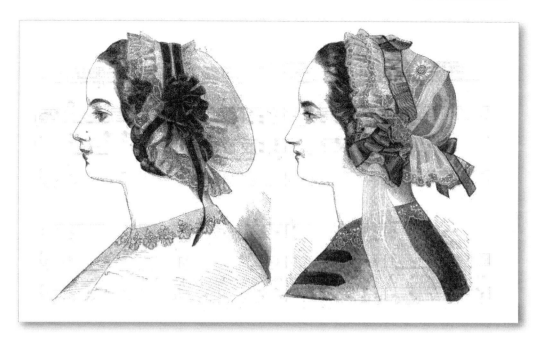

Figure 1 is one of the latest shaped breakfast caps; it is made from dotted mull. The ruffles are of lace. It is trimmed with black velvet, and is very petty for light mourning. Figure 2. Breakfast cap made of mull muslin and worked insertions. The ruffles are edged with a narrow thread lace. It is trimmed with ribbon, any shade the taste of the wearer may desire. Godey's Lady's Book. July 1861.

An article in the African American newspaper, *The Christian Recorder* of 1863, presents a visit to a mourning clothing store. While shades of black and gray were available, the reporter was surprised to see gloves in colors ranging from light lavender to brilliant red (acceptable when mourning a distant relation).[39]

Even in the privacy of their homes, ladies wore elements of mourning. *Godey's Lady's Book* advised that day caps and breakfast caps (caps worn in the morning) were to be trimmed with black velvet for light mourning. In August 1861, the magazine suggested wearing clear white with black or mauve and royal purple mixed with black.[40]

Widows generally wore black clothing including undersleeves and black crape drapery for the first year. In the second year of mourning, some white was introduced in undersleeves and collars. In 1861, black crape veils sold for $1.50 with lace veils worth $1.00.[41]

Fashions for Mourning.

For Deep Mourning, bombazine is considered the most suitable material, though delaine is very much worn, as less expensive. For summer wear there are innumerable material of the barege family; but these must all be made over black. Black alpaca is a most suitable article for mourning, except for the very deepest kind of black, when its glossiness is objectionable. But nothing can supply its place as a traveling-dress, or a "knock-about" dress, where there is likely to be much dust, as it throws it off so easily. For a lighting kind of mourning, plain black silks can be worn with propriety; but they should be of the kind styled "dead black," that is , without any glass. Then come the different kinds of purples, grays, lilacs and mixtures of black and white. Or black may be trimmed with purple, white, or gray' or these colors may have trimmings of black, according to the relationship of the person, or the length of time the mourning has been worn. For deep mourning, such as for a parent, husband, or any other near relative, the trimmings should be of crape only, and but little of even that. It is totally inadmissible to have much trimming in "deep black." The plainer the dress is, the more suitable. Black collars and sleeves are indispensable in such mourning, as well as black crape bonnet and veil. But when the relative is not so near, or when the deeper mourning has been laid aside, think plain white collars and sleeves are permitted, more trimming can be worn on the dress, the skirt may be ruffled or otherwise trimmed, and purple or white flowers worn in the face of the bonnet. With this lighter kind of mourning, a silk coat or sacque may be worn, or even a black shawl with a colored border, provided the colors are not too gay. As the season advances, white straw bonnets may be worn, trimmed with black, or even with white or purple, with purple pansies or violets in the face; but if the mourning is deeper, the bonnet should be of black straw, trimmed with crape or ribbon."[38]

Establishments such as J.S. Chase and Company of Boston specialized in providing mourning clothing and other items. All sorts of goods were sold from clothing pieces such as collars and armbands to black hat pins and buttons. If a person couldn't afford new mourning attire, they bought second-hand items or rented them. Individuals usually didn't retain their mourning clothes. They were discarded.

Grieving wasn't just represented by dress. Women wrote notes on black-edged stationery and even purchased card photographs with black borders. Death rituals included gifts, usually rings or pins, which were given out at funerals.

Accessories such as jewelry made from jet, a black gemstone (or cheaper black glass), as well as pieces that incorporated human hair also signified mourning. While not all jewelry that features hair represented a deceased person, it was a popular way to honor the memory of the dead. Rings, pins, and lockets with typical mourning symbols such as graveside scenes or weeping willows indicate a mourning piece. Men often wore mourning rings, given out as tokens at funerals.

Barre Gazette. January 31, 1862.

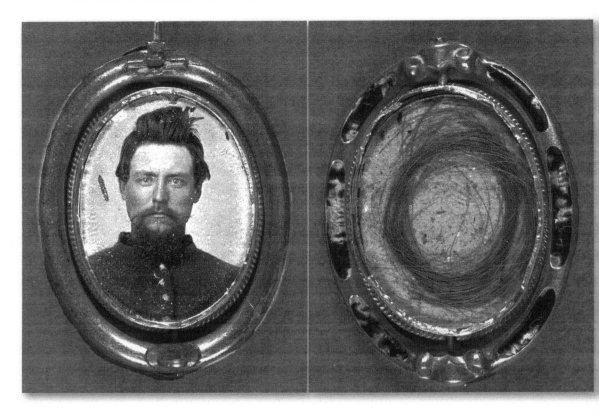

Front and back views of a brooch depicting an unidentified Union soldier. Mourning jewelry often contains a lock or braid of hair.

Postmortem photos

It was not unusual during the Civil War years for photographers to specialize in photographing the deceased. Photographers visited homes or the deceased were transported to their studios. The deceased was sometimes depicted as sleeping on a pillow, or posed with a flower. Infants and small children were photographed in their parent's arms.

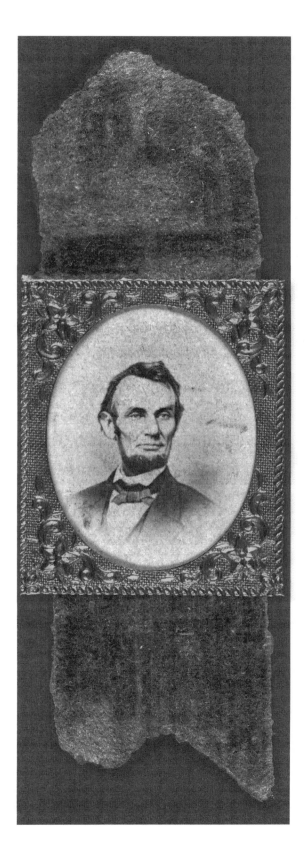

The assassination of President Abraham Lincoln in April 1865 led the country to mourn as one. There are numerous mourning pieces featuring Lincoln. A paper print in an ambrotype mat mounted on a piece of black fabric. According to the cataloging record, this photograph was taken for a political campaign button on February 9, 1864 by photographer Anthony Berger. It was attached to a blue velvet ribbon after Lincoln's assassination.

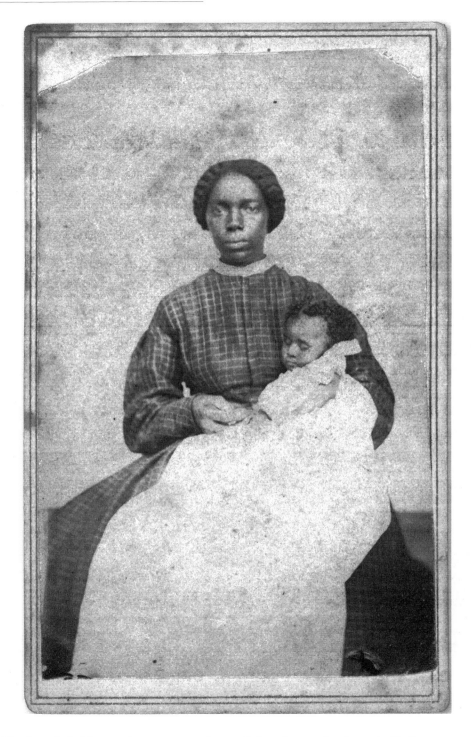

Unidentified African American mother with her deceased infant. A. D. Jaynes, Photographer. Corning, N. Y.

This unidentified woman wears a mourning brooch and holds a framed image of an unidentified soldier. Mourning jewelry usually incorporated a lock of hair of the deceased. 1861-1865.

This man dressed in a white tie and tails for his wedding, while his bride chose a light colored silk dress and a veil with a crown of flowers. This type of attire suggests that this was a couple with economic means. The Bachrach studio copied an earlier image to create this paper print.

CHAPTER 8

Weddings

Spotting a wedding photograph taken during the Civil War era requires studying the details and verifying genealogical information. In the 1860s, weddings were private events with the bride and groom and a few family members in attendance. Few photographs exist of actual wedding ceremonies. The common practice was for the couple to be photographed afterwards.

Godey's Lady's Book declared in the June 1849 issue, "Custom, from time immemorial, has decided on white as its proper hue, emblematic of the freshness and purity of girlhood."[42] In the 1860s, white continued to be a popular choice but it was a color usually worn by the affluent.

During the Civil War, some brides elected to wear purple dresses as a symbol of virtue and valor to honor the deceased soldiers. Silk, satin and Brussels lace were designated for wedding dresses. However, most women married in their best dress or in a traveling dress made of a simple color. The usual accessories of veil and gloves for women remained part of the ceremonial attire. Grooms sported dress suits with white vests and ties.

According to the newspaper accounts, Queen Victoria wore a lace robe and veil for her 1840 wedding. On her head was a "wreath of orange flowers and a small diamond pin, by which the nuptial veil was fastened to her hair."[43] The Queen set a new standard for Victorian brides for decades to come with her white wedding dress, but not all could afford a dress to be worn a single time.

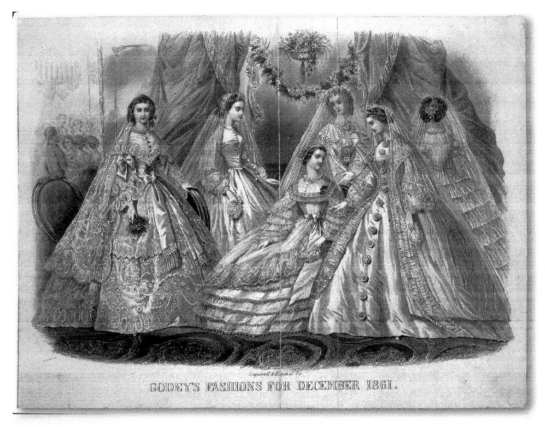

GODEY'S FASHIONS FOR DECEMBER 1861.

"The **wedding-dress** was of rich white corded silk, the skirt seven yards wide, with demi-train; the bottom was ornamented with a double **ruche** of crape **acrophane**set on in alternate squares and points of about twelve inches deep, corsage pointed, with a **berthe** formed by two rows of rich point lace, headed by a crape ruche, narrower point lace in the neck, drawn by a silver cord, the centre ornament a spray of orange buds and blossoms; veil of **thulle**, very ample and entirely bordered by a corresponding ruche of crape, which sustained it in its place. Wreath, mounted diadem-fashion, of white clematis, very fine and close, a spray of orange buds in the centre, and a cache **peigne** of orange buds at the back of the head. Among the reception dresses was one of lilac silk skirt gored, and very wide, each gore was distinguished by a band of violet-colored velvet, cut crosswise, corded with white silk and edged with blonde lace. Every two bands approached each other in the centre, narrowing as they rose, and were looped under each other in the form of a bow at the height of twenty-four inches from the bottom of the skirt. Corsage low and pointed, trimmed with a pointed berthe in violet velvet, edged in the same way. Between the point of the berthe and the top of the corsage was a stylish velvet bow, trimmed to correspond. Sleeves, a full puff of thulle, caught up by bands of trimmed velvet. Valenciennes edging in the neck, drawn to shape by violet chenille. A robe de chambre of the style called Marquise; the front is gored, a la Gabrielle, the back straight and full, set into a plain yoke on the shoulder by three or four square wide plaits, which are not confined by the girdle, which is a **cordelier**, fastened under

the arm on each side, and knotted in front. From the knee there is a single flounce, running all round, headed by a ruche of rose-colored ribbon. Sleeves loose and ample, edged simply by a ruche of ribbon. Material, fine plaid of black and white silk. There were some pretty muslin **spencers**, with the flat plaiting or ruche in the neck that is now so much worn, the plain place between the groups of plaits filled by bows of exceedingly narrow ribbon, also the new style of closed undersleeves, white, with a tongue of black lace and velvet extending half way to the elbow, at the back of the arm."[44]

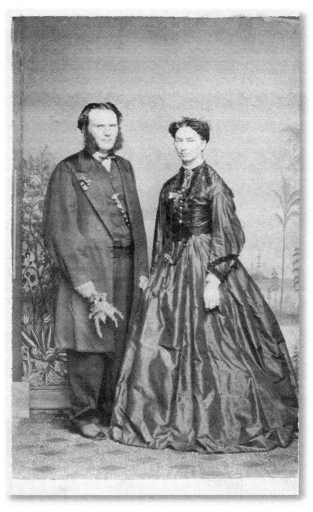

In this early 1870s image, the presence of the floral spray held by the man and the small **nosegays** pinned to their bodices suggest it's a wedding image.[46] He wears a formal frock coat while she's in a silk dress trimmed in braid. Though this image wasn't taken during the Civil War, it is a good example of what typical brides and grooms wore for their weddings. The large chain necklace worn by the bride was popular in the 1870s.

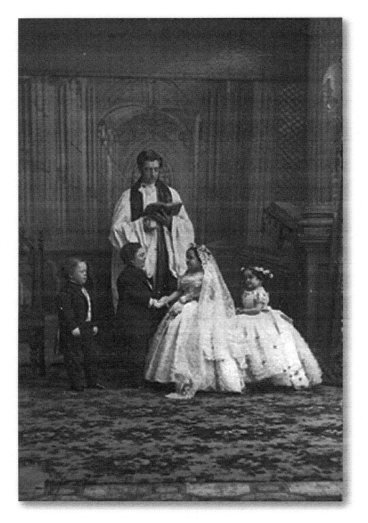

The wedding of Charles Sherwood Stratton, aka Tom Thumb and Lavinia Warren, February 1863. This re-enactment was published and sold. Different versions of the scene were used as a lithograph on sheet music.

Women's fashion magazines like *Godey's Lady's Book* described wedding dresses and featured them in fashion plates. Long translucent veils decorated with orange blossoms and wreaths of flowers were common. Brides typically changed from the wedding dress worn for the ceremony into another outfit for the reception.

The most famous wedding of the 1860s was the marriage of General Tom Thumb (Charles Stratton) and Minnie (Lorinia) Warren. Both were part of P.T. Barnum's show and well known to the American public. Their marriage in April 1863 was a spectacle. Warren's dress was designed and made by Madame

Demorest, at her establishment in New York City. Their wedding vows were exchanged at a church with two thousand people present. Instead of a reception at home, Stratton and Warren held their event at a hotel. All expenses were paid for by Barnum. Unlike other weddings of the time, the media was present and the *New York Times* and newspapers around the country published the details. The couple posed for multiple images that were later sold by E. & H.T. Anthony under the title of "The Fairy Wedding." Individuals purchased cartes de visite of the couple in their wedding attire, the bridal party, and even scenes in the church.[45]

Unlike the elaborate Tom Thumb event, weddings for couples separated by military service were simple affairs. There were even weddings held in encampments.

A Flag Made of Wedding Dress

Mrs. John C. Breckinridge, according to a circulating item, has cut up her wedding-dress and made a flag, which has been presented to the Twentieth Tennesee Regiment, in her husband's brigade for distinguished services.[47]

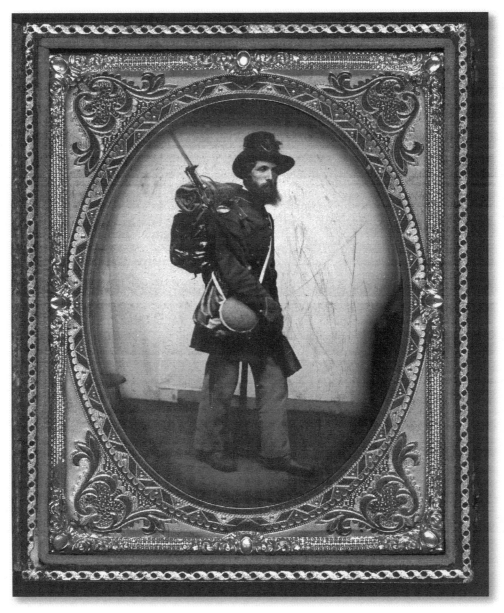

Private Albert H. Davis of Company K, 6th New Hampshire Infantry Regiment in uniform and Hardee hat. He's carrying a Model 1841 Mississippi rifle, a sword, bayonet as well as a bedroll, canteen and haversack. A haversack is similar to a backpack but it has a single strap.

CHAPTER 9

Uniforms

Contrary to what I learned in grade school, the uniforms worn during the Civil War were not just blue and gray. Soldiers wore a wide variety of colors and designs, with each unit having its own uniform. You might discover that your Union ancestor wore standard military dress of a cap and blue coat or find that he donned a uniform based on a design from a European army – tartans from Scotland or the Algerian-derived **Zouave** outfits of wide pants and fez caps. There was even clothing diversity within the units.

Unit battle uniforms, dress attire and military school garments all varied in look and color which makes identification even more difficult. Try Robin Smith and Ron Field's *Uniforms of the Civil War* or the comprehensive *Encyclopedia of United States Army Insignia and Uniforms* by William K. Emerson. When examining Civil War photos of men in uniform, don't overlook the obvious – Civil War belt buckles usually carried an abbreviation of the state of enlistment or the letters CSA, signifying the Confederate States of America.

At a glance you'll be able to identify your soldier's rank by examining the cloth chevrons on the sleeves and shoulders of a uniform and the insignia on their collar or headgear. In addition, after 1863, badges or insignia pins identified the corps the soldier served with. Navy uniforms feature hash marks or cloth stripes on the sleeves for sets of years of service. Philip Katcher's *The Civil War Source Book* contains extensive illustrations of buttons and sleeve markings. Start deciphering the costume clues by breaking the uniform down into pieces, establishing a date for each piece based on its unique characteristics.

Artillery officers wore buttons with a spread eagle and the letter A on the shield. Infantry officers wore the letter I and cavalry, the letter C. State regiment insignia in the form of state seals often appeared on coat buttons and belt buckles.

Clues to military dress also appear in period newspapers. For instance, according to an 1861 article, United States Army Chaplains wore a plain nine-button black frock coat, plain black pantaloons, and a black felt hat while New York's Regiment of sharp-shooters wore a colorful emerald green coat with sky blue trousers.[48]

In 1860, Marcellus Hartley and two other partners established the Schuyler, Hartley & Graham Sporting Goods Company. It became the largest sporting goods company in the world, but during the Civil War, they supplied goods and clothing to the Union armies. Their 1864 *Illustrated Catalogue of Arms and Military Goods: Containing Regulations for the Uniform of the Army, Navy, Marine and Revenue Corps of the United States*, (Dover publications edition, available used) contains illustrations for everything from buttons to weapons and insignia.

Identifying Military Uniforms

Headgear

The wide variety of headgear worn during the Civil War was based on the unit or branch in which a man served and on their status as officers or enlisted men. Puffed **Whipple** caps, slouch hats, broad brimmed low crowned felt hats, standard issue forage caps, Hardee hats, and a style known as the McDowell cap that had a bump in the back were all common. You can see examples of these cap styles in *A Guide to U.S. Army Dress Helmets, 1872-1904*.

During the Civil War, soldiers wore long crowned kepis or hats that were wider at the bottom and featured branch insignia letters on the front. Mark Kasal and Don Moore's *A Guide Book to U.S. Army Dress Helmets, 1872-1904* is invaluable for identifying headgear. Cavalry regiments wore wide brimmed tall crowned **Hardee** hats, designed by William Hardee, who was a Lieutenant General in the Confederate Army and a West Point graduate. The brim of this

What is a Zouave?

Doesticks says he is "a fellow with a red bag having sleeves to it for a coat; with two red bags without sleeves to them for trousers; with an embroidered and braided bag for a vest; with a cap like a red woolen saucepan; with yellow boots like a fourth robber in a stage play; with a mustrasche [sic] like two half pound brushes, and with a sort of sword gun or gun-sword for a weapon that looks like the result of a love affair between an amorous sword and a lonely musket, indiscreet and tender—that is a Zouave. A fellow who can 'pull up' a hundred and ten pound dumb-bell; who can climb up an eighty-foot rope, hand over hand, with a barrel of flour hanging to his heel who can do the 'giant swing' on a horizontal xx with a fifty-six tied to each ankle; who can xx up four long flights of stairs, holding a heavy man in each hand, at arm's length; and who can climb a greased pole feet first, carrying a barrel of port in his teeth—that is a Zouave. A fellow who can jump seventeen feet four inches high without a spring board; who can tie his legs in a double bow-knot round his neck without previously softening his shin-bones in a steam bath; who can walk Blondin's tight rope with his stomas of nine brandy cocktails, a suit of chain armor outside his stomach, and a stiff north-east gale outside of that; who can take a five shooting revolver in each hand and knock the spots off the ten of diamonds at eighty paces, turning summersaults all the time and firing in the air—that is a Zouave.[49]

hat was generally pinned up on the right side for cavalry and artillery and on the left for infantry. A feather and a wool cord decorated these hats.

Jackets, Shirts and Pants

Shirts were cotton or linen while pants and jackets were usually woolen. The lack of a standardized uniform caused confusion for men serving on both sides. Pants worn by Federal troops were light blue, but their jacket colors varied. Confederate soldiers wore black, gray, blue or butternut. With a scarcity of resources by 1863, Confederate soldiers wore cast-off northern uniforms or pants made from linen canvas, cottonade, or tent cloth. Officers generally wore

Military Clothing

The volunteers having been placed on the same footing as regards the regulars, relative to clothing, the following information in published for their instruction: Primate (sic) army soldiers are allowed one uniform hat each year, price $1; one forage cap each year, price 57 cents; one uniform coat each year, price $656; three pair of trowsers (sic) the first year, two the second, and three the third, price $2.82 per pair; two sack coats each year. price each, $2.10; three flannel shirts each year, price 90 cents each; one overcoat in five years, price $6.40; three pairs of drawers the first year, two every other year, price 71 cents each pair, four pair of brogans each year, price $2.20 per pair; two blankets in five years, price $2 44 each.

There are a variety of other article supplied, but these are the chief ones. In order to encourage economy and cleanliness among the troops, every article not drawn according to the allowance will be paid for to the solider. So every man now in the ranks will probably receive pay for the clothes he wears, as they were not furnished by the Bureau of Clothing.[52]

nine-button frock coats with rank insignia on the shoulders. According to Emerson's *Encyclopedia of United States Army Insignia and Uniforms*, company-grade officers also wore single-breasted coats while the coats of field grade officers had two rows of seven buttons. Frock coats hung to the knee.[50]

Decoration

Cloth chevrons on the sleeves and shoulders of a uniform and insignia on the collar or headgear signified rank. Starting in 1863, badges or insignia pins worn on the headgear identified the Corps in which the soldier served. In the Navy, hash marks or cloth stripes on the sleeves stood for sets of years of service. A portrait of your ancestor in full dress uniform would include medals, braids, ribbons, and even sashes depending on the time period. Confederate uniforms used collar devices to designate rank based on the number of stars.

Weapons and Equipment

If the soldier posed with his full gear, look carefully at the type of sword or firearm he carried and don't forget to analyze his everyday equipment. Each element is an important detail. A man carrying a carbine rifle is probably part of the cavalry while a man equipped with a pistol could be an officer. The majority of soldiers carried muskets.

Confederate

Confederate guerrillas wore whatever they wanted. Since they weren't sanctioned by the Confederacy and worked outside the Confederate military establishment, they weren't issued any uniforms. Originally, some Confederate troops wore Federal blue uniforms but gradually the southern armies generally adopted gray or a butternut color.

According to an 1862 Boston newspaper article, a circular found on a battlefield describes uniforms for Confederate officers:

"Officers of the field are permitted to wear a fatigue dress, consisting of the regulation frock coat, without embroidery on the collar, or a gray jacket with the designation of rank upon the collar. Only caps such as are worn by the privates of their respective commands may be worn by officers of the line."[51]

Uniform Confusion

Careful study of a uniform is important but it can still be difficult to date your photo based on caps, shirts or pants alone. Civil War uniforms and caps were worn both during and after the end of the war. Compare your pictures to images in this book and others mentioned in the bibliography. Then add up all your clues — type of image, photographer's dates, and family information to make sure they agree.

Veterans

Do you know if any of your ancestors joined a veterans group after the Civil War? Clues to your ancestor's military service may be a little hard to see without enlarging the image. They might be wearing evidence of their membership on their jacket lapel in the form of a small pin or a badge.

One such veteran's group, the Grand Army of the Republic (GAR) was founded in 1866 in Decatur, Illinois, for honorably discharged Union veterans

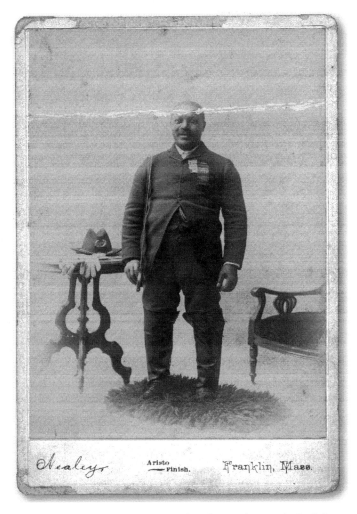

Grand Army of the Republic member. His hat bears the symbol of the group and he has two GAR ribbons pinned to his jacket. Photographer Nealey. Franklin, Massachusetts. Circa 1893-1896.

of the Civil War. GAR posts held encampments, multi-day events which often included camping out, formal dinners and memorial events. Nationwide, the group also founded soldiers' homes and was active in relief work and in pension legislation, according to the Sons of Union Veterans of the Civil War website [suvcw.org]. Membership peaked at 400,000 in 1890 and the organization didn't dissolve until 1956. Many of its members wore uniforms and caps which were manufactured especially for GAR members. A typical uniform consisted of a double-breasted, dark blue coat with bronze buttons, and a black slouch hat decorated with a gold wreath and a cord. [53]

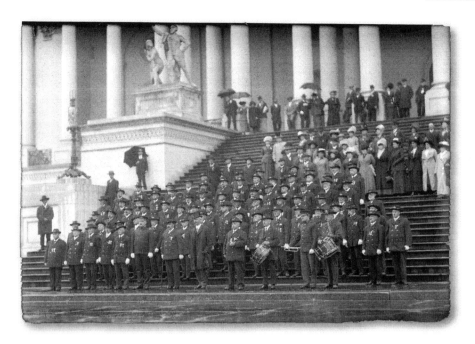

Grand Army of the Republic group. Possibly August 29, 1888.

There was an organization for the children of these veterans. Established in 1915, The Children of the Grand Army of the Republic aimed to honor and maintain the memory of the men who'd served in the Civil War.

If you own a group portrait of men and women standing in front of Mount Vernon, home of George Washington, it could be a reunion picture for a Grand Army of the Republic group since many Civil War veterans groups visited there. Gettysburg was also the site of many veterans' reunions.

Gallery of Images

The captions for this group of photos are derived from the Library of Congress cataloging record. For additional Civil War images see the Library of Congress website [www.loc.gov] and select Digital Catalog. The LOC is digitizing the Liljenquist Family Collection of Civil War soldiers. This amazing cache of 700 photos was donated to the library in 2010.

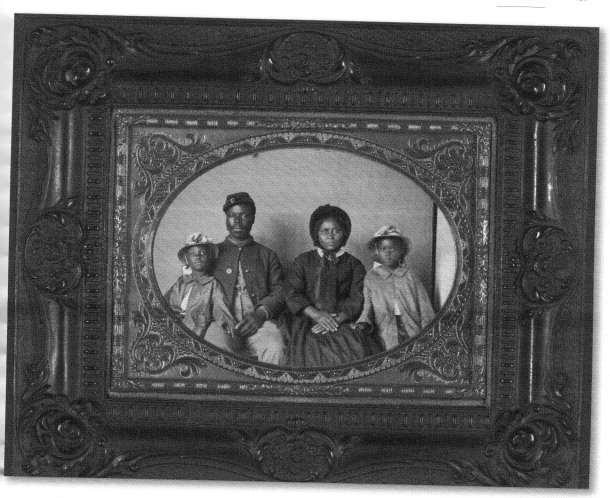

Unidentified African American family. In May 1863, U.S. Secretary of War Edwin Stanton issued General Order No. 143 establishing the Bureau of U.S. Colored Troops (USCT). According to the Library of Congress cataloging note this image may depict a soldier of one the Maryland units of the USCT.

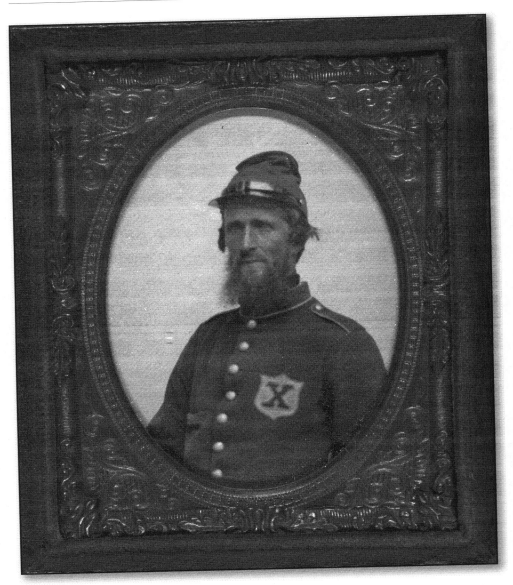

Unidentified man wearing uniform of the 56th New York Volunteers (10th Legion) and a style of headgear known as a forage cap.

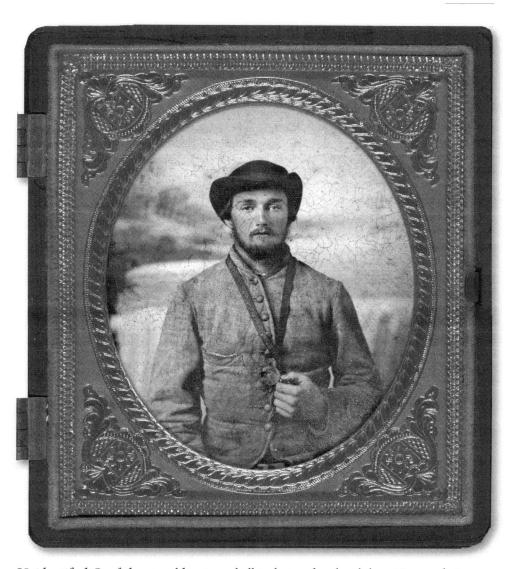

Unidentified Confederate soldier in a shell jacket and a slouch hat. He stands in front of a waterfall backdrop.

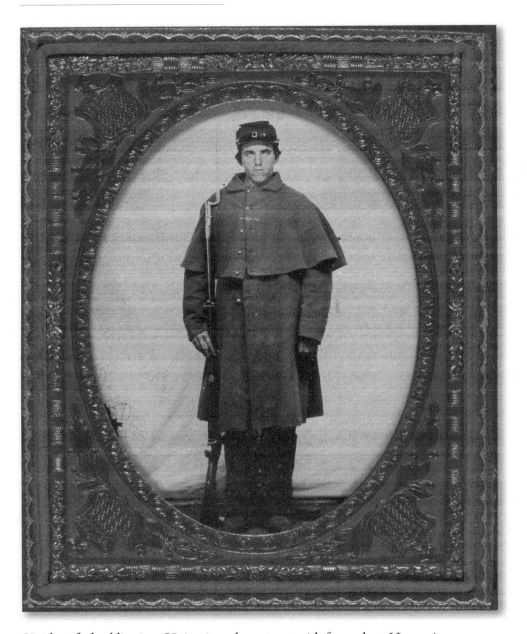

Unidentified soldier in a Union issued greatcoat with forage hat. He carries a musket with a bayonet.

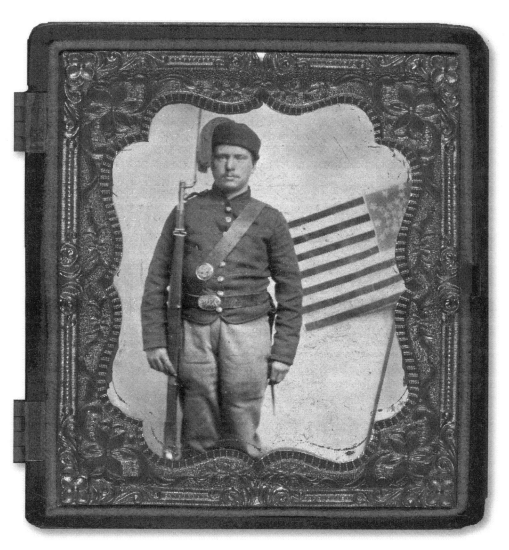

Soldier in a Union uniform wearing fez cap usually worn by Zouaves. He's carrying a musket with a bayonet. The photographic backdrop features an American flag.

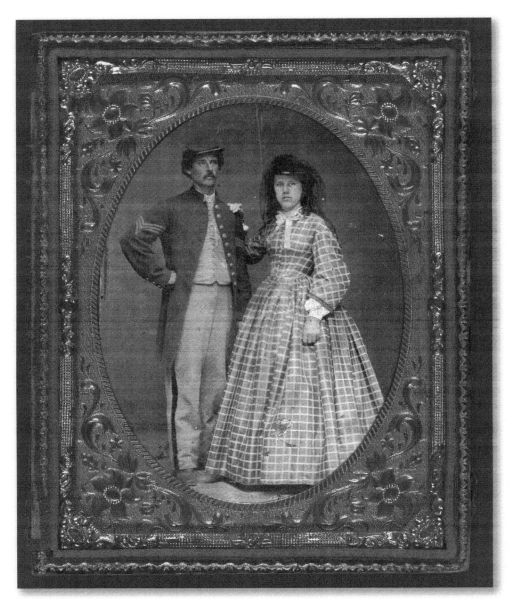

Unidentified couple. The man wears a Union uniform and the woman's hat has a veil.

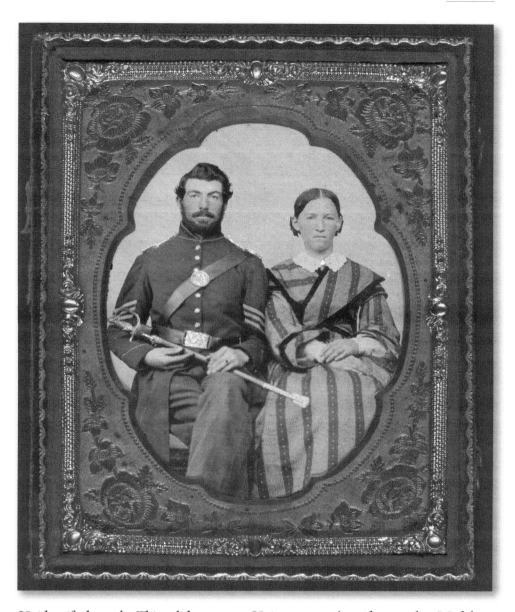

Unidentified couple. This solider wears a Union sergeant's uniform with a Model 1840 non-commissioned officer's sword.

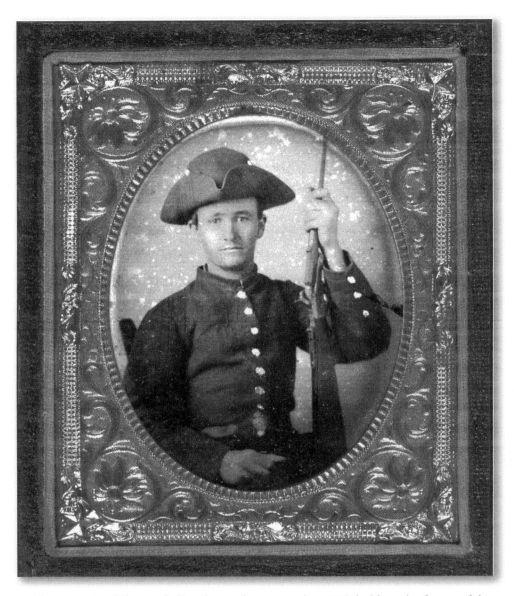

Soldier in a Confederate shell jacket and a tricorn hat. He's holding the first model Maynard carbine.

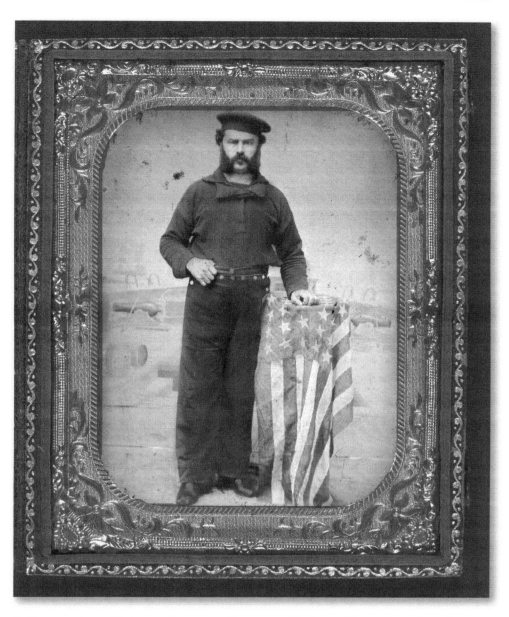

Sailor wearing a Union uniform standing at a table draped in an American flag. The backdrop depicts a naval ship.

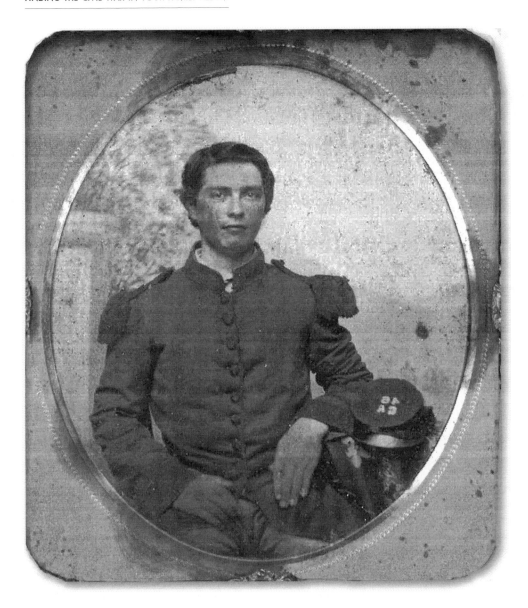

The identification on his hat is a key clue—he's with the 46th Georgia Infantry. Notice how the letters and numbers are reversed. The owner of the image, Pat Layton, is looking at the Civil War material online at Footnote.com hoping to locate additional information. She's still not sure who he is, but she's closer to an answer. She thinks he might be Lt. Thomas Davis.

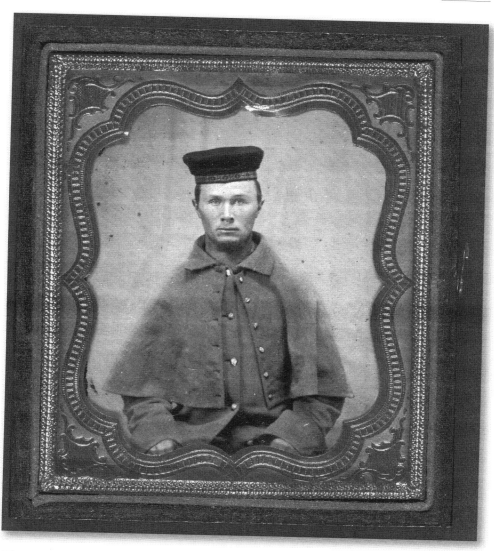

This image depicts a man in the 12th Illinois Volunteers, "The First Scotch Regiment" in greatcoat and tam-o'-shanter cap.

On the back of this photograph taken in June 1863, the studio advertises as a Photographic Art Gallery. While clients waited their turn, they could gaze at photographs on display.

CHAPTER 10

Researching Photographers

In the 1860s, photographers operated studios in cities and towns all over America. In rural regions, traveling photographers brought their skills to customers wherever they lived. Once the war began, photographers set up shop near encampments while others followed the troops, taking pictures of Civil War battlefield death.

There was money to be made from photographing the famous and reselling their likenesses. In 1861, the *Boston Transcript* wrote that, "any photographer who would follow the army…and be fortunate enough to obtain views of battles, or even skirmishes, would make a fortune by sale of copies."[54]

One of the most famous photographers of that era was Mathew Brady. He was well known before the first shot was fired. He'd opened his first daguerreotype studio in 1844 in New York City. While today, the images from Mathew Brady's studio are synonymous with the war, few were actually taken by Brady himself due to his poor eyesight. His employees traveled with Lincoln's armies photographing the war and adding to Brady's reputation. In the 1860s, thousands of photographs were taken at Mathew Brady's New York and Washington studios. Given the number of people his operatives photographed, you may own a Brady-labeled image.

Turn over your Civil War era image and you're likely to find a photographer's name and address. Most imprints during the 1860s were simple advertisements, sometimes embellished with decorative elements. Information was usually written in up to three lines. The ink was usually black but other

Photo taken
July 22d
1861

BRADY
The Photographer
returned from
Bull Run

Mathew Brady upon his return from Bull Run. July 22, 1861.

colors such as red, brown and purple were not unknown. Most imprints can be found on the reverse side of images. Only rarely were they on the front. Occasionally, you'll find a rubber-stamped imprint.

If an imprint contains the note, "negatives preserved," don't jump to conclusions. Very few of these negatives still exist. Try contacting the local historical society in the area in which the photographer did business, but it is unlikely that you'll find their negative collection.

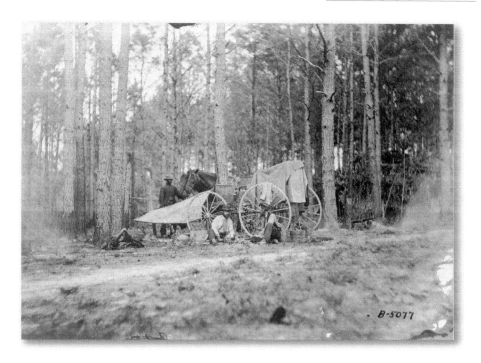

One of Brady's photographic wagons, a portable studio.

A Selection of Imprint Styles

During the Civil War, brothers Edward and Henry Anthony purchased publishing rights to images by Brady and offered stereo cards and cartes de visite. These collectible images were purchased in sets or single prints from book sellers, but the Anthony brothers also sold directly to the consumer through newspaper and magazine ads as well as catalogs of images for sale. On this CDV back, the company advertised that they manufactured photo albums.

This is the inside of a daguerreotype case showing advertising for the manufacturer. Included is a list of patents relevant to Littlefield, Parsons & Co.

Many imprints in the Civil War period appeared in three lines of text.

A lovely decorative frame surrounds Cole's name and address.

Photographers used imprints to advertise that they'd taken over older studios. In this case, DeLamater tells his potential clients that they can find him "3 doors above the P.O."

Trott used the symbol of an eagle as a patriotic element on his imprint.

This particular imprint includes a negative number to assist in reordering photographs.

Photographers quickly realized that business income could be earned from folks asking for additional prints. The following phrase appears along the bottom. "Additional copies from the place from which this print is taken can be had if desired." In the center of Brown's imprint is the anchor, the symbol for the state of Rhode Island.

A simple decorative pattern surrounds Gregory's claim as an artist.

Researching the Photographer

The information in the imprint can help you research the photographer. Knowing when and where a photographer worked can help you more specifically date an image in your collection. You may be able to determine an exact time period for the photographer's work dates. Armed with that information, you can then determine who's depicted in your family photo. There are many ways to locate additional material on these photographers.

Google

Type the name of the photographer, address and place of operation into the search box. Use quote marks to eliminate extraneous hits.

Published and Web-Based Directories

There is no single resource for finding information on photographers. Finding Photographers.com [www.findingphotographers.com] is useful but limited in scope. There are many published volumes on photographers in various states. I suggest using Amazon.com or another online bookseller to locate a source appropriate for your search. Another option is to ask a reference person at a local historical society in the area in which the photographer worked if any such publication exists. You might find a book, an article in a scholarly journal or a web resource.

Craig's Daguerreian Registry [craigcamera.com/dag/]

Try this online resource for daguerreotypists, but because those studios sometimes also took ambrotypes and other types of images, it's worth searching for photographer name. Work dates and variant spellings are often included in the list.

City Directories

Nineteenth-century city directories contain listings of persons by surname followed by their address and sometimes their business name and occupation. Business directories in the back pages are very helpful when trying to determine work dates. Unfortunately, there is no one online resource for city directories. Try both Ancestry.com and Footnote.com to see if the directories you seek are digitized. If not, directories are usually available on microfilm or

microfiche and you can purchase them through Gale/Cengage Learning [www. gale.cengage.com/]. Historical societies and public libraries often maintain collections of city directories. If you can't access them, consider hiring a professional genealogist. A list of genealogists appears on the Association of Professional Genealogists website [www.apgen.org].

Newspapers

Newspaper databases searched by individual names can turn up news items, obituaries, and sometimes advertisements relating to the photographer. There are many different online newspaper databases – Ancestry.com, Genealogybank.com [www.genealogybank.com] and Readex Early American Newspapers (available through library subscription) are popular options.

Local Historical Societies

Historical societies usually maintain collections of images taken in their area. In some cases, volunteers and staff members have files or information on the photography studios that operated locally. Check their websites for online image catalogs and reference information.

Reunion Sites

Use online image databases such as reunion sites (Dead Fred.com, Ancient Faces.com or Missing Photographs.com) to find other images taken by the same photographer. You might locate one with a date.

Web-Based Databases

It's also worth searching genealogy databases such as Ancestry.com for family information on the photographer or to search other large image resources such as Flickr [www.flickr.com] and the Library of Congress [www.loc.gov]. The International Museum of Photography at the George Eastman House maintains a telnet database of photographers that users can access through the website [www.geh.org/gehdata.html]. If you use an Apple computer, you may not be able to access the information. See the note on their website.

Searching newspaper databases for information on photographers often yields more than an address. R.S. Delamater outlined his services in this advertisement.

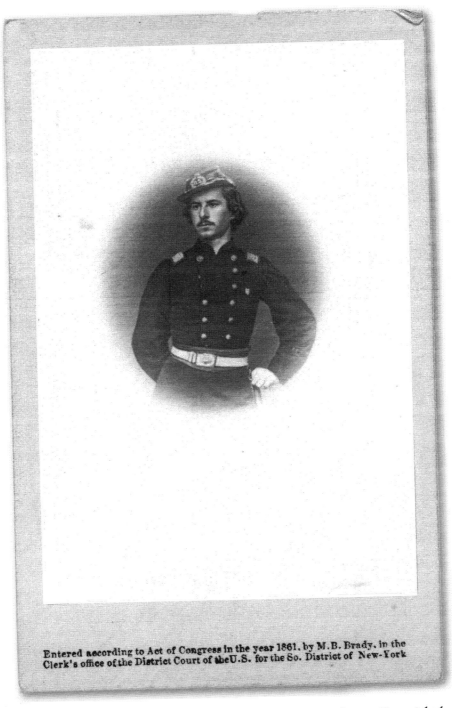

Elmer Ellsworth, Colonel of N.Y. Fire Zouaves, E & H. Anthony. Copyright by Mathew Brady, 1861.

CHAPTER 11

A Gallery of
Iconic Civil War Images

The first Union casualty of the war was Colonel Elmore Ellsworth, a former clerk in President Abraham Lincoln's law office and a close family friend. He was killed while taking down a flag at the Marshall House, an Alexandria, Virginia inn. Ellsworth had his portrait taken at Brady's Washington studio prior to leaving for the front. Upon hearing the news of his death, Anthony and Brady quickly compiled a photographic memorial featuring Brady's portrait of Ellsworth, the Marshall House and Francis Brownell, the soldier who killed the man who had assassinated his officer. [56]

There are photographs that are so striking they become representative of a time period. I've selected several of these Civil War images for this chapter because either the image, the story behind it or both are iconic. These details remain with you long after you've turned the page.

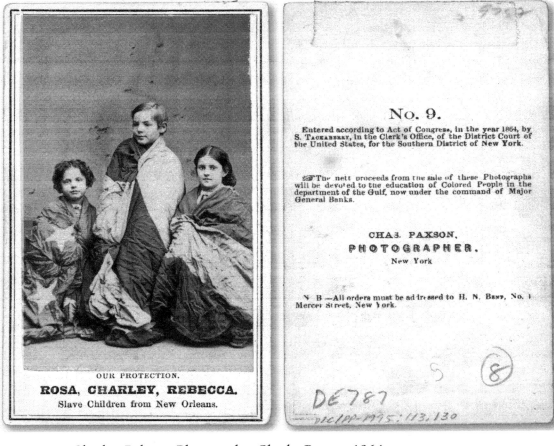

Rosa, Charley, Rebecca. Photographer Charles Paxton, 1864.

The American Missionary Association and the National Freedman's Relief Association featured eight students in a series of photographs. Notice that the photographer posed them wrapped in American flags – a symbolic gesture so that viewers would identify them as Americans, too. Their light colored skin and slave heritage brought home the message that these children could be your own. These images generated donations for the cause of free public education for former slaves.[55]

On the reverse of the card, printing includes a copyright notice and the following statement: "The net proceeds from the sale of these Photographs will be devoted to the education of Colored People in the department of the Gulf, now under the command of Major General Banks."

Photographs of War Injuries

Injuries inflicted by battle were a grim reality of war. This set of images was taken by the War Department between 1861 and 1865. The United States Army Military Medical Department photographed the effects of war such as injuries, illness and amputations. After the war ended, the images were published in the *Medical and Surgical History of the War of the Rebellion* (a six volume set). [57]

Photographs show men displaying the wounds received during the Civil War. Upper left: John Brink, Private, Company K, 11th Pennsylvania Cavalry (Surgical photo 208). Upper right: Sergeant Warden (Surgical photo 207). Lower left: Samuel H. Decker, Private, Company I, 9th U.S. Artillery (Surgical photo 205). Lower right: Allison Shutter, Drummer, Company C, 7th Pennsylvania Reserves (Surgical photo 204). (Source: M. Rhode, Army Medical Museum, 2009). Caption courtesy of the Library of Congress.

Negative by T. H. O'SULLIVAN, Entered according to act of Congress, in the year 1865, by A. GARDNER, in the Clerk's Office of the District Court of the District of Columbia. Positive by A. GARDNER, 511 7th St., Washington.

Incidents of the War.

A HARVEST OF DEATH.

Gettysburg, July, 1863.

Incidents of the war. A harvest of death, Gettysburg. July, 1863. Published by Philp & Solomons. Circa 1865.

Battlefield Scenes

The most famous photograph of the war is likely Timothy O'Sullivan's "Harvest of Death" which shows Union soldiers' bodies scattered over the Gettysburg field.

The Humiston Children

Since many men carried photographs of loved ones with them at all times, it's not surprising that men who died on the battlefield were found in possession of these images. Newspaper stories fed the public imagination and brought the war home in new ways. Probably no family photo of the war is more famous than the ambrotype held by Amos Humiston while he lay dying. Humiston perished during the Battle of Gettysburg, grasping a picture of three small children. His body was identified on the basis of that image. Newspapers ran detailed descriptions of the children with captions asking for information on their father. The story drew the attention of Dr. John C. Bournes of Philadelphia who paid for thousands of copies and sent them throughout New England and the Mid-Atlantic. Eventually, the mother of those children saw the description and discovered that her husband was dead. This picture captured the nation's interest and became the incentive to raise money to build an orphanage at Gettysburg. Additional pictures of the children were sold to raise funds for a National War Orphans Homestead.[58]

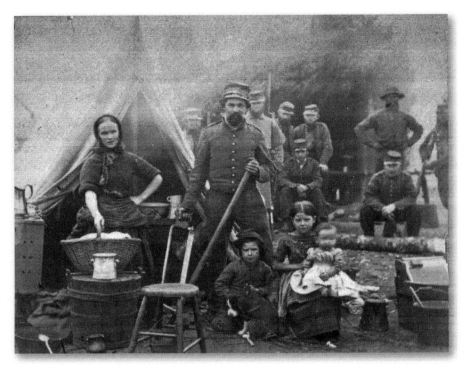

Camp of 31st Pennsylvania Infantry near Washington, D.C. Woman with sleeves rolled up holding basket, posed in front of tent with a soldier (possibly her husband) and three children. 1862.

Women in the War

During the war, women at home knitted stockings for soldiers, but some, like this woman, accompanied men to the encampments. Other women such as Clara Barton served as nurses, and a few like Mary Walker (See image in Chapter 4) were doctors. Then there were women who enlisted posing as men such as Loreta Janet a Velazquez a.k.a. "Lieutenant Harry Buford".

Velazquez was born in Cuba, but joined the war fighting for the Confederates under an assumed name in 1861. Her husband, who was also serving, was unaware that she'd enlisted. She participated in the Battle of Bull Run, Ball's Bluff and Fort Donelson before being discovered. She reenlisted and when found out for the second time, became a spy, dressing variously as a man and a woman. [59]

Loreta Janet a Velazquez a.k.a. "Lieutenant Harry Buford."

Search online databases to locate family photographs like this image of a Mrs. Tynan and her sons of Frederick, Maryland.

CHAPTER 12

Finding Your Civil War Ancestor's Photo

If you don't own any photographs of your family taken during the Civil War, don't despair. Start by networking with relatives to see what they have in their collections. Then try the following resources.

United States Army Military History Institute

[carlisle-www.army.mil/usamhi/PhotoDB.html]
The largest collection of military images from the Mexican-American War (1846-1848) to the present is located at the United States Army Military History Institute, [www.ahco.army.mil/site/index.jsp]. Search their digital collection and then order copies of any relevant images. In the 1880s, the Massachusetts group, Military Order of the Loyal Legion of the United States, set out to collect images of the war. In the 1970s, these images became part of the United States Army Heritage and Education Center (USAHEC) at Carlisle Barracks, Pennsylvania. Frances Trevelyan Miller's 1911/1912 *Photographic History of the Civil War* pictures as well as those borrowed and copied for the publication were donated to USAHEC as well.

Library of Congress

The Library of Congress Prints & Photographs division, found online at [www. loc.gov], has an extensive collection of Civil War images. To find these images, start on the main page and follow these steps:

+ Select "Digital Collections"
+ Select "Prints and Photographs"
+ Search by specific name, military unit or just browse using the "Gallery View" option

Images with a white border may be downloaded. "Civil War Images" is a featured collection on the initial search page. While you're on the site, also check out the American Memory Project, a collaborative endeavor with historical societies all over the United States.

Historical Societies and Archives

U.S. Military Records: A Guide to Federal and State Sources by James C. Neagles contains more than a dozen listings for archives with photographic collections. Use online search engines to find their websites. Then start looking for images. Two excellent pictorial resources are the digital collection at the Virginia Military Institute (VMI) [www.vmi.edu/archives] and the Museum of the Confederacy [www.museumoftheconfederacy.com]. The National Archives [www.archives.gov] partnered with Footnote.com [www. Footnote.com]. You can search and view Civil War images on both websites for free.

Leave Messages

Post queries on military-related message boards. For instance, search for messages relating to your family on boards.ancestry.com. Include basic information about the soldier in your post such as full name and his life dates.

Reunion Sites

Use online photo reunion sites such as Dead Fred [www.deadfred.com] or
Ancient Faces [www.ancientfaces.com]. Read genealogist Midge Frazel's success
story:

*In July of 2007, I decided to investigate the popular Web site, DeadFred.
com as I was writing a column for my local genealogical society's newsletter.
When presented with an alphabetical list of letters representing surnames, I
immediately went to the letter S.*

*Much to my surprise, there were several links to photographs for the
surname Schofield or Scholfield. Thinking that there must be many people
descended from the Schofield brothers who came to Boston from their native
England carrying the plans for their woolen mill in their head in May of
1793, I never expected to be presented with a photograph of Joseph A.
Schofield, my 2nd great grandfather!*

*After gazing at the photograph for several minutes, I opened my box of
family photographs, found a photo of his daughter Ellen, who was called
Nellie. In the photograph she must be about the same age as her father.
The likeness is remarkable. Both have the same dark circles under their
eyes. I search DeadFred.com again and find a photograph of Joseph's sister,
Elizabeth, wife of Charles Mann. She also has the dark circles under her
eyes.*

*Some months later, I receive copy of a photograph of my other 2nd great
grandfather, taken in the same photography studio as Joseph Schofield. The
pose, the chair and the curtain are identical. This photography studio was
probably the Schofield Brothers who specialized in portraits!*

*Joseph served in the 5th Regiment Connecticut Volunteer Infantry,
Company G during the Civil War. He enlisted as a Private on 21 June
1861, enlisting in Company G on 22 July 1861 and reenlisted on 21
December 1863. He was promoted to full Corporal on 22 July 1864 and
mustered out on 19 July 1865 in Alexandria, VA. His pension card lists
his wife's name and an invalid claim 1890 July 11, and widow claim 1917
March 14.*

Joseph A. Scholfield. Collection of Midge Frazel.

Re-enactment Groups

Contact re-enactment groups, many of which collect historical material, to obtain information on your ancestor's regiment. A simple search using an Internet tool like Google.com can connect you with others interested in the history of a group.

Social Media

Don't ignore the possibilities of finding descendants of your Civil War ancestors using social media sites like Flickr [www.flickr.com], FaceBook [www.facebook.com] or Twitter [www.twitter.com]. Start by entering surnames in their search boxes.

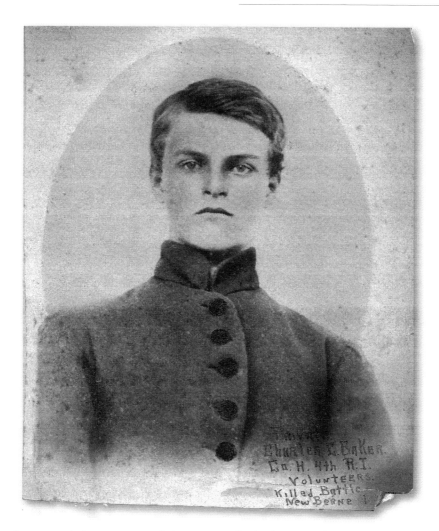

Genealogist Rachel Pierce owned this image of Charles C. Baker of North Kingstown, RI. This young man was the first Civil War casualty for the town. He was only 17. He'd served with the 4th Rhode Island Co. H.

eBay

Set up an alert for your surname so you won't miss auctions that might include "lost" family items, photographs included.

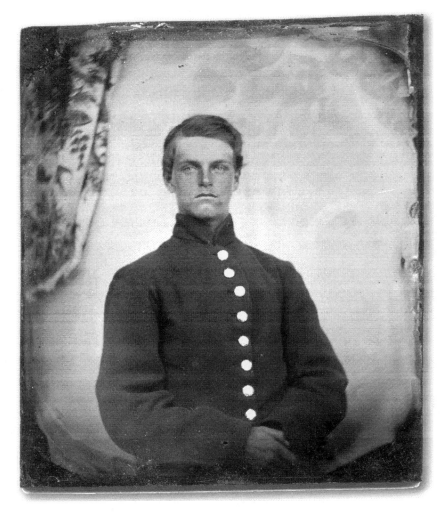

One day while searching on eBay, Pierce discovered another image of him.

Keep Searching: Three Civil War Specific Websites

+ CivilWarPhotos.net has a searchable database of 1,200 photos. [www.
 civilwarphotos.net]
+ A good resource for information on Civil War photography is the non-
 profit Center for Civil War Photography. [www.civilwarphotography.
 org]
+ Another option is American Civil War Photo Gallery. [www.civilwar-
 pictures.com/]

Endnotes

1 Keith F. Davis, *The Origins of American Photography, 1839-1885 From Daguerreotype to Dry-Plate* (Kansas City, Missouri: Hall Family Foundation in association with the Nelson-Atkins Museum of Art, 2007) p. 174.

2 For additional information on daguerreotypes, ambrotypes and tintypes see Maureen Taylor, *Uncovering Your Ancestry Through Family Photographs* (Family Tree Books, 2005) and *Preserving Your Family Photographs* (Picture Perfect Press, 2010).

3 Martha A. Sandweiss, editor. *Photography in Nineteenth-Century America.* (New York: Harry N. Abrams and the Amon Carter Museum of Art, 1991) p. 144. "Dating Old Photos," 23. Jan. 2011. <www.billblanton.com/date.html>.

4 John Hannavay, ed. *Encyclopedia of Nineteenth-Century Photography* (New York: Routledge. 2008) pp. 275-276.

5 Richard F. Selcer, *Civil War America, 1850-1875, Almanacs of American Life* (Facts on File, 2006) p. 375.

6 Sandweiss, *Photography in Nineteeth-Century America*, p. 148.

7 Sandweiss, *Photography in Nineteenth-Century America*, p. 147.

8 "How to Make Magic Lantern Slides by the Process of Diaphanie," January 2, 1863, *Public Ledger* (Pennsylvania), p. 4.

9 "A Wonderful Experiment—Photograph of a Murdered Man's Eye," *Milwaukee Sentinel*, October 14, 1863, p. 3.

10 "New Style of Photograph," *Hartford Daily Courant*, January 1, 1863, p. 2.

11 "Photograph Albums," *Oregonian*, August 30, 1862, p. 1.

12 Ibid.

13 "Photograph Albums. Where and By Whom They are Made, Rapid Growth and Recent Extent of," *Springfield* (Massachusetts) *Republican*, December 31, 1864, p. 3.

14 "American Photograph Albums," *Springfield* (Massachusetts) *Republican*, March 28, 1862, p. 3.

15 William C. Darrah, *Cartes de Visite in Nineteenth Century Photographs* (Gettysburg, PA: W. C. Darrah, 1981) p. 87. James E. Kloetzel and William Jones, *Scott's Specialized Catalog of United States Stamps* (Scott Publishing Co, 2009).

16 Peter Chrisp, *History of Fashion and Costume*. Volume 6: The Victorian Age (Bailey Publishing, 2005) pp. 22-23.

17 Slavery and the Making of America, 17 Jan. 2011, < http://www.pbs.org/wnet/slavery/index.html>.

18 "How to dress for a photograph," *New Orleans Times*, April 9, 1865, p. 2.

19 Joan Severa, *Dressed for the Photographer: Ordinary Americans & Fashions* (Kent State University Press, 1995) p. 196.

20 "The Garibaldi Shirt," *Godey's Lady's Book*, March 1862, p. 228.

21 *Sandusky* (Ohio) *Register*, December 9, 1861, p. 3.

22 "An Empress Editor," *Albany Evening Journal*, October 4, 1862, p. 4.

23 "Hoop Skirts. Where they Came From—and Where They are Going To, *Springfield Republican*, March 12, 1864, p. 3.

24 Moving Westward," *Illustrated New Age*, May 31, 1864, p. 2.

25 "Singular Skating Accident," *Albany Evening Journal*, February 10, 1863, p. 2. "Danger of Hoops," *Sun*, January 7, 1864, p. 1. News story, *Plain Dealer*, July 14, 1865, p. 4.

26 Clothing for Slave Children in Slavery and the Making of America, 17 Jan. 2011, <http://www.pbs.org/wnet/slavery/experience/gender/feature3.html>.

27 *Peterson's Magazine*, September 1864, p. 216.

28 "Paper Neck-ties and Collars," *Farmer's Cabinet*, January 18, 1861, p. 1.

29 Advertisement, *Springfield Republican*, May 7, 1864, p. 5.

30 Maureen Taylor, "Texas Twosome Revisited," Photo Detective, 5 Jan. 2010. <blog.familytreemagazine.com/photodetectiveblog/2010/01/05/TexasTwosomeRevisited.asp>.

31 14 Jan. 2011, < www.AmericanCenturies.mass.edu/activities/dressup>.

32 Winthrop L. Marvin, ed. *Bulletin of the National Association of Wool Manufacturers, Volume 40* (Boston: National Association of Wool Manufacturers, 1910) p. 182.

33 "Flannel," *Augusta Chronicle*, August 21, 1862, p. 2.

34 "Fashion and Shaving Brushes," *Farmer's Cabinet*, December 26, 1861, p. 1.

35 The Spring Fashions, *New York Herald*, March 22, 1861, <www.accessible.com>, 17 Jan. 2011.

36 Ibid.

37 Mary Brett, Fashionable Mourning Jewelry, Clothing and Customs (Atglen, PA: Schiffer, 2006) pp. 85-88.

38 "Fashions for Mourning," *Peterson's Magazine*, May 1862, p. 426.

39 "Fashionable Mourning. The Habiliments of Grief, From a Commercial Point of View," *The Christian Recorder*, 19 Sep. 1863, < www.accessible.com >, 20 Dec. 2010.

40 Chitchat Upon New York and Philadelphia Fashions for August, *Godey's Lady's Book*, August 1861, <www.accessible.com>, 20 Dec. 2010.

41 Advertisement, *Hartford Daily Courant*, July 22, 1861, p. 4.

42 Etiquette of Trousseau No. 3, *Godey's Lady's Book*, June 1849.

43 "Marriage of Queen Victoria, February 10, 1840," *New-Bedford Mercury*, March 13, 1840, p. 1.

44 *Godey's Lady's Book*, September 1861.

45 "The Wedding of Gen. Thom Thumb and Miss Warren," *Pacific Commercial Advertiser*, April 23, 1863, p. 4. "The Fairy Wedding!" *Farmer's Cabinet*, February 19, 1863, p. 3.

46 Collection of the Author.

47 "A Flag Made of a Wedding Dress," *Sun*, March 24, 1863, p. 1.

48 "Uniforms for Army Chaplains," *Pittsfield Sun*, December 12, 1861, p. 2. "New York Regiment of Sharpshooters," *New York Herald*, November 10, 1861, p. 2.

49 "What is a Zouave?" *Farmer's Cabinet*, May 17, 1861, p. 1.

50 Dorothy Denneen Volo and James M. Volo, *Daily Life in Civil War America* (Westport, CT: Greenwood Press series "Daily Life Through History", 1998) p. 140.

51 "Officers in the Field," *Boston Daily Advertiser*, October 13, 1862, p. 2.

52 "Military Clothing," *Daily National Intelligencer*, June 3, 1861, p. 3.

53 "The Grand Army of the Republic and Kindred Societies," <www.loc.gov/rr/main/gar/garintro.html>, 2 Feb. 2011.

54 "Photographic Views of the Army," *Boston Transcript*, June 10, 1861, p. 2.

55 Davis, *Origins of American Photography*, p. 196.

56 Davis, *Origins of American Photography*, p. 176.

57 Darrah, *Cartes de Visite in the Nineteenth Century*, p. 78.

58 Darrah, *Cartes de Visite in the Nineteenth Century*, pp. 84-85. Mark H. Dunkelman, *Gettysburg Unknown Soldier: The Life, Death and Celebrity of Amos Humiston*. New York: Praeger, 1999.

59 Hispanic Americans in the United States Army, <www.army.mil/hispanicamericans/english/profiles/valasquez.html> 6 Jan. 2011.

Glossary

Acrophane (also known as aerophane): A type of crepe fabric available in various colors such as pink and white.

Berthe: A wide collar of lace.

Bombazine: A type of fabric made from silk or a combination of silk and wool.

Bretelles: Suspenders

Cassimere: A plain or twilled woolen fabric. It is a variant spelling for cashmere.

Cordelier: A thick cord that ties around the waist.

Day Cap: When a young woman married, she began wearing a muslin or linen cap over her hair while indoors.

Ditto Suit: A suit with matching jacket, vest and pants.

Eton Cap: A cap with a short visor.

Fanchon: A lace trimmed bonnet.

Guimpe: Lace insert for a low-cut dress or a blouse worn under a pinafore.

Hardee Hat: A wide brimmed tall crowned hat, named for William Hardee, a Lieutenant General in the Confederate Army and a West Point graduate. The brim of this hat was generally pinned up on the right side for cavalry and artillery and on the left for infantry. A feather and a wool hat cord decorated these hats.

Haversack: A single strapped pack for carrying equipment.

Kepi Cap: A flat round hat with a visor worn by military units during the Civil War.

Knickerbocker Pants: Loose fitting pants banded around the knee.

Marquise Robe: A wide loose fitting robe.

Nosegay: A small bouquet of flowers.

Nubias: A type of fabric.

Pagoda Sleeves: Sleeves that widen at the elbow. Worn with undersleeves in the summer.

Paletot: A type of jacket worn outdoors. Long versions were fitted and extended past the knees. Shorter versions were available.

Palmetto: A variety of palm leaves.

Peigne: A comb worn on the back of the head for evening events.

Ruche or **ruching:** Gathered trim of lace or other fabric.

Ryestraw: Stalks of rye that could be woven into straw hats.

Sack or **sacque:** A loose fitting coat or a loose fitting men's suit coat.

Selvedge: The finished edges of fabrics that prevents unraveling.

Slouch Hats: A wide brimmed felt hat usually worn by soldiers.

Solferino: A color named after an Italian town, close to the contemporary fuschia color.

Soutache Braid: A narrow flat braid used on dresses in the late 1860s and on military uniforms.

Spencers: A short jacket trimmed with fur.

Tattersall: A checked wool fabric.

Thulle: A type of fabric, probably a variant spelling of tulle.

Valenciennes: Bobbin lace that originated in Valenciennes, France.

Whipple Caps: Patterned by J. F. Whipple of Boston in July 1861. It was actually designed by another hatter, James M. Loomis of Chicago. These felt hats protected the head and neck. Its wide brim could be buttoned up. New England troops initially wore these caps. More information is available in *U.S. Army Headgear 1812-1872.*

Zouave: A uniform worn during the Civil War derived from Algerian uniforms featuring loose pants, and a fez cap.

Bibliography

Books and Articles

"A Wonderful Experiment—Photograph of a Murdered Man's Eye." *Milwaukee Sentinel.* October 14, 1863.

Advertisement. *Hartford Daily Courant.* July 22, 1861.

Advertisement. *Springfield Republican.* May 7, 1864.

"An Empress Editor." *Albany Evening Journal.* October 4, 1862.

"A Flag Made of a Wedding Dress." *Sun.* March 24, 1863.

Baldwin, Gordon. *Looking at Photographs: A Guide to Technical Terms.* Malibu, CA: J. Paul Getty Museum in association with British Museum Press. 1991.

Brett, Mary. *Fashionable Mourning Jewelry, Clothing, & Customs.* Atglen, PA: Schiffer Publishing Co. 2006.

Cheroux, Clement et al. *The Perfect Medium: Photography and the Occult.* New Haven, CT: Yale University Press. 2005.

"Chitchat Upon New York and Philadelphia. Fashions for August," *Godey's Lady's Book,* August 1861. <www.accessible.com> 20 Dec. 2010.

Chrisp, Peter. *History of Fashion and Costume.* Volume 6: The Victorian Age. New York: Facts on File. 2005.

Cumming, Valerie, C.W. Cunnington and P.E. Cunnington. *Dictionary of Fashion History.* New York: Berg. 2010.

Darrah, William C. *Cartes de Visite in Nineteenth Century Photographs.* Gettysburg, PA: W. C. Darrah. 1981.

Davis, Keith F. *The Origins of American Photography, 1839-1885 From Daguerreotype to Dry-Plate.* Kansas City, Missouri: Hall Family Foundation in association with the Nelson-Atkins Museum of Art. 2007.

Davis, William C., Editor. *Touched By Fire: A National Historical Society Photographic Portrait of the Civil War.* New York: Black Dog & Levanthal. 1997.

Dunkelman, Mark H. Gettysburg *Unknown Soldier: The Life, Death and Celebrity of Amos Humiston*. New York: Praeger, 1999.

"Elmer Ellsworth. Mr. Lincoln's White House. 4 Oct. 2010. <www.mrlincolnswhitehouse.org>.

Emerson, William, K. *Encyclopedia of United States Army Insignia and Uniforms*. University of Oklahoma Press. 1996.

Etiquette of Trousseau. No. 3. *Godey's Lady's Book*. June 1849.

"Fashion and Shaving Brushes.'" *Farmer's Cabinet*. December 26, 1861.

"Fashionable Mourning. The Habiliments of Grief, From a Commercial Point of View." *The Christian Recorder*. 19 Sep. 1863. <www.accessible.com> 20 Dec. 2010.

"Fashions for Mourning." *Peterson's Magazine*. May 1862.

Faust, Drew Gilpin. *This Republic of Suffering: Death and the American Civil War*. New York: Alfred A. Knopf. 2008.

"Flannel." *Augusta Chronicle*. August 21, 1862.

Frassanito, William A. *Early Photography at Gettysburg*. Gettysburg, PA: Thomas Publication. 1995.

Gardner, Alexander. *Gardener's Photographic Sketch Book of the Civil War*. New York: Dover Publication. 1959.

Hannavay, John, Editor. *Encyclopedia of Nineteenth-Century Photography*. New York: Routledge. 2008.

Hartley, Marcellus. *Illustrated Catalogue of Arms and Military Goods: Containing Regulations for the Uniform of the Army, Navy, Marine and Revenue Corps of the United States*. Dover Publications. 1864.

Haythornthwaite, Philip. *Uniforms of the Civil War*. Sterling Publishing. 1990.

Henisch, Heinz K. and Bridget A. *The Photographic Experience, 1839 - 1914: Images and Attitudes*. University Park, PA: Pennsylvania State University Press. 1994.

"How to dress for a photograph." *New Orleans Times*. April 9, 1865.

"How to Make Magic Lantern Slides by the Process of Diaphanie." January 2, 1863. *Public Ledger* (Pennsylvania).

Kasal, Mark and Don Moore. *A Guide Book to U.S. Army Dress Helmets, 1872-1904*. North Cape Publications. 2000.

Katcher,Philip. *The Civil War Source Book*. Facts on File.1992.

Kloetzel, James E. and William Jones. *Scott's Specialized Catalog of United States Stamps*. Scott Publishing Co. 2009.

Lamb Knitting Machine Advertisement. *Springfield Republican*. October 12, 1865.

Langellier, John P. and C. Paul Loane. *U.S. Army Headgear 1812-1872*. Atglen, PA: Schiffer Military History. 2002.

Leisch, Juanita. *Who Wore What? Women's Wear, 1861-1865*. Gettysburg, PA: Thomas Publications, 1999.

Lord, Francis A. *Uniforms of the Civil War*. Dover Publications. 1970.

"Marriage of Queen Victoria, February 10, 1840." *New-Bedford Mercury*. March 13, 1840.

Marvin, Winthrop L. ed. *Bulletin of the National Association of Wool Manufacturers, Volume 40*. Boston: National Association of Wool Manufacturers. 1910.

"Military Clothing." *Daily National Intelligencer.* June 3, 1861.

Neagles, James C. *U.S. Military Records: A Guide to Federal and State Sources.* Ancestry. 1994.

"New Style of Photograph." *Hartford Daily Courant.* January 1, 1863.

"New York Regiment of Sharpshooters." *New York Herald.* November 10, 1861.

"Officers in the Field." *Boston Daily Advertiser.* October 13, 1862.

"Paper Neck-ties and Collars." *Farmer's Cabinet.* January 18, 1861.

"Photograph Albums. Where and By Whom They are Made, Rapid Growth and Recent Extent of." *Springfield (Massachusetts) Republican.* December 31, 1864.

"Photographic Views of the Army." *Boston Transcript.* June 10, 1861.

Ries, Linda A. and Jay W. Ruby. *Directory of Pennsylvania Photographers 1839-1900.* Commonwealth of Pennsylvania: Pennsylvania Historical and Museum Commission. 1999.

Sandusky (Ohio) *Register.* December 9, 1861.

Sandweiss, Martha A., Editor. *Photography in Nineteenth-Century America.* New York: Harry N. Abrams and the Amon Carter Museum of Art. 1991.

Schimmelman, Janice G. *American Photographic Patents: The Daguerreotype & Wet Plate Era, 1840-1880.* Nevada City, CA: Carl Mautz Publishing. 2002.

Selcer, Richard F. *Civil War America, 1850-1875. Almanacs of American Life.* New York: Facts on File. 2006.

Severa, Joan L. *Dressed for the Photographer: Ordinary Americans and Fashion, 1840-1900.* Kent, Ohio: Kent State University Press. 1995.

Siegel, Elizabeth. *Galleries of Friendship and Fame: A History of Ninteenth-Century American Photograph Albums.* New Haven: Yale University Press, 2010.

Slavery and the Making of America. 17 Jan. 2011. <www.pbs.org/wnet/slavery/index.html>.

Smith, Robin and Ron Field. *Uniforms of the Civil War: An Illustrated Guide for Historian, Collectors and Reenactors.* The Lyons Press. 2005.

Taylor, Maureen. *Fashionable Folks: Hairstyles 1840-1900.* Westwood, MA: Picture Perfect Press. 2009.

Taylor, Maureen. *Preserving Your Family Photographs.* Westwood, MA: Picture Perfect Press. 2010.

Taylor, Maureen. "Texas Twosome Revisited." Photo Detective. <blog.familytreemagazine.com/photodetectiveblog/2010/01/05/TexasTwosomeRevisited.asp>. 5 Jan. 2010.

Taylor, Maureen. *Uncovering Your Ancestry Through Family Photographs.* Cincinnati, OH: Family Tree Books. 2005.

"The Fairy Wedding!" *Farmer's Cabinet.* February 19, 1863.

"The Spring Fashions." *Augusta Chronicle.* April 21, 1863.

The Spring Fashions. *New York Herald.* March 22, 1861. 17 Jan. 2011. <www.accessible.com>.

"The Wedding of Gen. Thom Thumb and Miss Warren." *Pacific Commercial Advertiser.* April 23, 1863.

"Uniforms for Army Chaplains." *Pittsfield Sun.* December 12, 1861.

United States Army Military Medical Department. *Medical and Surgical History of the War of the Rebellion.* 1861-1865.

Volo, Dorothy Denneen and James M. Volo. *Daily Life in Civil War America.* Greenwood Press series "Daily Life Through History" Westport, CT: Greenwood Press. 1998.

Wallace, Carol McD. *All Dressed in White: The Irresistible Rise of the American Wedding.* New York: Penguin. 2004.

"What is a Zouave?" *Farmer's Cabinet.* May 17, 1861.

Magazines

Godey's Lady's Book

Peterson's Magazine

Websites

Ancestry.com <www.ancestry.com>

Accessible Archives <www.accessible.com>

Civil War Photography <www.civilwarphotography.org>

Family Tree Magazine <www.familytreemagazine.com>

Footnote.com <www.footnote.com>

GenealogyBank <www.genealogybank.com>

Library of Congress <www.loc.gov>

Making a Photograph During the Brady Era <www.npg.si.edu/exh/brady/animate/photitle.html >

National Archives <www.archives.gov>

Pictures of the Civil War National Archives <www.archives.gov/research/military/civil-war/photos/index.html>

Wet-Plate Photography, The Wizards of Photography PBS <www.pbs.org/wgbh/amex/eastman/sfeature/wetplate_step1.html>

List of Illustrations

Cover Images (clockwise): African American Family Library of Congress, AMB/TIN no. 5001; Confederate soldier, Courtesy of Pat Layton; Unidentified children, Collection of Jane Schwerdtfeger; Unidentified soldier and woman, Liljenquist Family Collection, Library of Congress AMB/TIN no. 2; group portrait, Collection of Jane Schwerdtfeger; Unidentified soldier, Liljenquist Family Collection, Library of Congress AMB/TIN no. 2064.

Cover Center Image: Courtesy of Whit Middleton

Images are listed by page number.

36. F.R. Grumel, "Photographic Album," US Patent 32,287, May 14, 1861. Accessed on Google.com on December 27, 2010.

37. Collection of the author.

38. Library of Congress, Lot 12255.

40. Collection of the author.

40. Collection of the author.

41. Collection of the author.

41. Collection of the author.

42. Collection of the author.

43. Collection of the author.

44. *Godey's Lady's Book*, August 1864, p. 160.

47. *Godey's Lady's Book*, January 1864, back cover.

48. *Godey's Lady's Book*, January 1864, p. 15.

49. Library of Congress, Unprocessed in PR 13 CN1975:071.

51. *Godey's Lady's Book*, February 1864, p. 126.

52. *Godey's Lady's Book*, February 1864, p. 191.

53. *Godey's Lady's Book*, September 1864, p. 254.

54. *Godey's Lady's Book*, March 1862, p. 228.

55. Library of Congress, LOT 9934, p. 15.

56. Alexander Douglas and S. S. Sherwood, "Improvement in Ladies' Skirts," US Patent 34,568, March 4, 1862. Accessed on Google.com December 27, 2010.

58. *Godey's Lady's Book*, October 1864, p. 343.

59. Collection of the author.

60. Collection of the author.

61. Collection of Jane Schwerdtfeger.

63. Library of Congress, LOT 14022, no. 45.

64. Library of Congress, Lot 12661.

66. Collection of Jane Schwerdtfeger.

66. Courtesy of Rachel Pierce.

67. Collection of the author.

68. Collection of Jane Schwerdtfeger.

69. Collection of the author.

70. Collection of Jane Schwerdtfeger.

71. Collection of the author.

72. Collection of the author.

73. Collection of Jane Schwerdtfeger.

74. William Gladstone Collection, Library of Congress, LOT 14022, no. 206.

76. *Godey's Lady's Book*, March 1861, p. 253.

77. Collection of the author.

78. Library of Congress, LOT 14022, no. 72.

79. Collection of the author.

80. *Godey's Lady's Book*, April 1860, p. 354.

81. Collection of Midge Frazel.

84. Collection of the author.

84. Collection of the author.

85. *Godey's Lady's Book*, August 1862, p. 181.

86. *Godey's Lady's Book*, December 1863, p. 506.

87. *Godey's Lady's Book*, March 1861, p. 257.

151. Library of Congress, Lot 4172-H.
153. William A. Gladstone Collection, Lot 14022 no. 324.
154. Liljenquist Family Collection, Library of Congress AMB/TIN no. 2260.
155. Collection of Jane Schwerdtfege.r
155. Collection of Jane Schwerdtfeger.
155. Collection of the author.
156. Collection of Jane Schwerdtfeger.
156. Collection of the author.
157. Collection of the author.
158. Collection of the author.
158. Collection of the author.
161. *Hartford Daily Courant*, December 11, 1863. Courtesy of GenealogyBank.com
162. Library of Congress, LOT 9934, p. 23.
164. William A. Gladstone Collection, Library of Congress LOT 14022, no. 130.
164. William A. Gladstone Collection, Library of Congress LOT 14022, no. 130.
165. Library of Congress, LC-DIG-ppmsca-10105
166. *Appears in Gardner's photographic sketch book of the war, vol. 1, p.36 Library of Congress* Library of Congress, Illus. in E468.7. copy 2
167. http://en.wikipedia.org/wiki/File:Pic01-Humiston-Children.jpg
168. Library of Congress, LOT 4172-C
169. United States Army <www.army.mil/hispanicamericans/english/profiles/ valasquez.html>
170. Library of Congress, LC-B817-7190
174. Collection of Midge Frazel.
175. Courtesy of Rachel Pierce.
176. Courtesy of Rachel Pierce.

Index

9452509R0

Made in the USA
Lexington, KY
29 April 2011